To Ransom —

Good Golfing!

Paul Mulozzewck

Texas Golf Legends

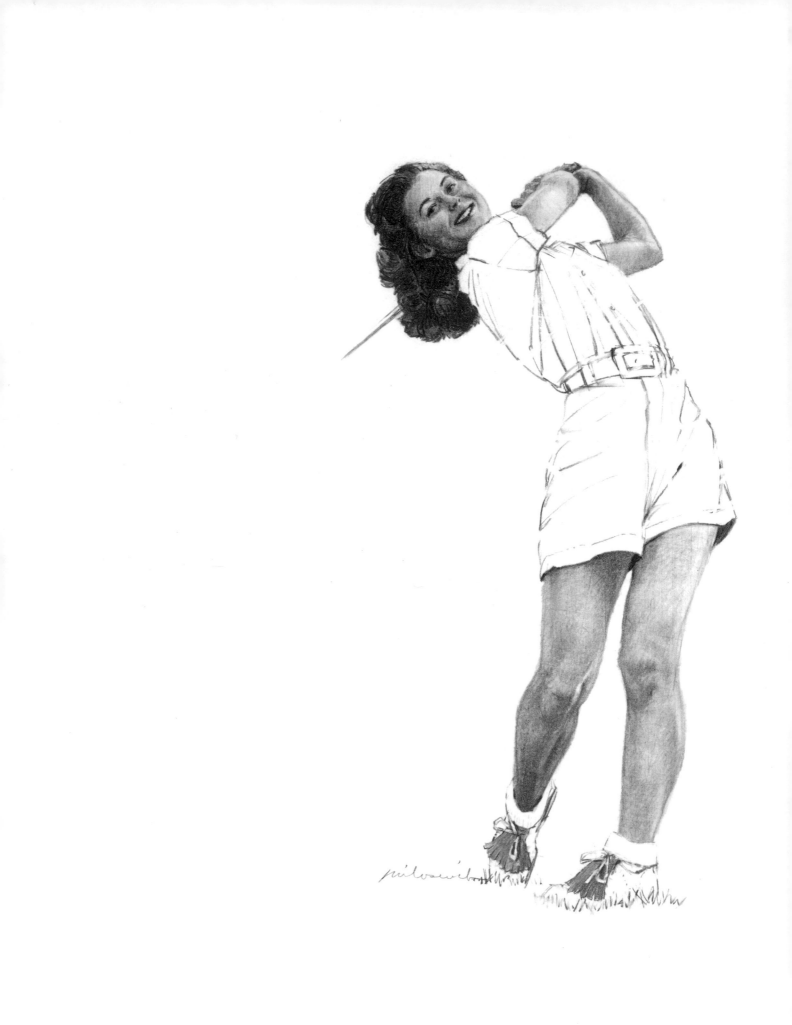

TEXAS GOLF LEGENDS

Portraits by Paul Milosevich • Text by Curt Sampson

Foreword by Ben Crenshaw • Introduction by Tom Kite

Texas Tech University Press

This book was set in 10 on 13 Trump Mediaeval and printed on acid-free paper that meets the guidelines for permanence and durability of the Committee on Production Guidelines for Book Longevity of the Council on Library Resources. ∞

Jacket and book design by Jim Billingsley

Manufactured in the United States of America.

Library of Congress Cataloging-in-Publication Data

Milosevich, Paul, 1936-
 Texas golf legends / portraits by Paul Milosevich ; text by Curt Sampson ; foreword by Ben Crenshaw ; introd. by Tom Kite.
 p. cm.
 ISBN 0-89672-298-8. — ISBN 0-89672-299-6 (pbk.)
 1. Golfers—Texas—Biography. I. Sampson, Curt. II. Title.
GV964.A1M55 1993
796.352′092—dc20 92-38712
[B] CIP

93 94 95 96 97 98 99 00 01 / 9 8 7 6 5 4 3 2 1

Texas Tech University Press
Lubbock, Texas 79409-1037 USA

Contents

Foreword

Texans, by nature, are a fierce, independent breed. They have had to endure many a hardship in any endeavor in the form of two formidable, timeless foes that Texans know too well: the weather and the land. Whether it be in the three realms of cattle, oil, or cotton, early Texans who made something of themselves in turn had an influence on all Texans. When golf really took off in Texas around 1920, this competitive spirit spilled over on the golf course. Simply put, if one can learn to play golf in Texas successfully, namely to really battle the elements of the weather and the land, one could play anywhere. Such golfers were ready for anything that came their way.

As a Texan, I feel a silent personal pride when someone mentions the names of Byron Nelson, Ben Hogan, Jimmy Demaret, and Jack Burke, along with great teachers such as Harvey Penick. These individualists spawned a legacy of Texas golf for generations to come. It would be the classic understatement to say that these great men spawned a proud legacy for all future golfers.

Paul Milosevich and Curt Sampson are the perfect pair to illustrate and describe the legends of Texas golf. Both have an acute sense of the true meaning of our heritage.

Ben Crenshaw

Preface

Why have there been so many great golfers from Texas? Is it just coincidence that the state that spawned Hogan, Nelson, Demaret, and Trevino also was home to Zaharias, Rawls, Haynie, and Whitworth? It's possible—but no one we asked thinks so.

"It's because Texas is a place with no restrictions," says Ladies Professional Golf Association great Kathy Whitworth. "I was always encouraged: 'Whatever you think you're big enough to handle, you take it.' It's a Western attitude."

"There's not a more sports-minded state or one that accentuates the individual more," says former Walker Cup star Don Cherry. "Golf's the most individual game. So we were bound to get great players."

The essence of Whitworth's and Cherry's observations—that Texas is somehow different from the other forty-nine states—was repeated by others we interviewed for this book. Texas, they reminded us, is the only state that was itself once a country, although those who remember the Republic of California might dispute this. "I think we've produced a high number of great players because, as Texans, we've learned to be tough," says 1984 Masters champion Ben Crenshaw. "By nature and by geography, it's part of our heritage. If you don't think a Texas farmer or cattleman is tough . . . " And one more thing, adds golf historian Crenshaw: "We've had fantastic people to provide shining examples: Hogan, Nelson, Demaret, Burke . . . "

Byron Nelson says his success was due partly to having learned golf from the bottom up. "All the players in our time learned through caddying," he says. "And we learned to play on hard Bermuda greens."

Lee Trevino's background is similar (though far from identical) to Nelson's. He was a caddy and a golf-course maintenance worker who taught himself to play on the unwatered, grainy surfaces at the municipal courses in Dallas. "So when I got on those courses in the East, man, they looked like pool tables," Trevino says.

Nearly everyone we talked to credited the spectacular Texas weather for creating so many top players. "There are all kinds of weather here, especially wind, especially in West Texas," says Harvey Penick, the best and best-loved instructor in the state, adding "I wouldn't play those West Texas players for a dime."

Best-selling author and journalist Dan Jenkins says "golf was always important in Texas. There were no big league sports for a long time—especially baseball—so only football and golf got attention. Which is the way it should be."

Other theories are espoused. Homero Blancas and Dave Marr say the great teachers and junior programs in the state are partly responsible. Others mention the college golf programs of Fred Cobb at North Texas State University and Dave Williams at the University of Houston. Jacky Cupit credits all the excellent golf courses in the state; Don January says it's the preponderance of *bad* golf courses that has made so many Texas golf champions. Betty Jameson says the Bermuda fairways in Texas make the ball sit up and encourage a good swing; Dick Forester says "you've got to beat down on the ball more in Texas" and *this* encourages a good swing. Betsy Rawls and Billy Maxwell say it's tradition; Kathy Whitworth believes the *lack* of tradition of golf in Texas was a benefit to her and others.

Keith Fergus says simply that Texas has had so many good golfers because "it's a big state with lots of people."

Why has Texas produced so many legendary golfers? Obviously, that is a question reasonable people—including the legends themselves—disagree on.

What also may be debatable is our inclusion or exclusion of certain people in this book. We knew such disagreement was inevitable, because of what this book is not. It is not an encyclopedia of Texas golfers, neither is it a history of golf in Texas nor a ranking of the best or best-known players from the state. *Texas Golf Legends* is, instead, a personal statement, limited to just fifty "legends."

Our selection process was completely subjective. A major requirement of our legends was that they inspire Paul Milosevich to paint and me to write; they had to be different. A passage from *The Last Lion,*

William Manchester's biography of Winston Churchill, stuck with me: "A legend can never be repeated, for part of its appeal is that it is unique. That is why there can never be another [King] Arthur, another Joan of Arc, another Lincoln."

Another tricky question was how to define "Texan." We decided not to be strict regarding birthplace or residence; if we associated a particular person with the Lone Star State, that was enough. For instance, if John Wayne had been a golfer, we might have considered him for this book.

We make no apology for the people we included in this book—none. Yet we know deserving people are not included here. We regret this deeply. Dan Jenkins, the ranking expert on Texas golf, proposed during a long lunch at his Juanita's restaurant in Fort Worth that the book was missing some of the people listed below. Perhaps, in a second edition of *Texas Golf Legends*, we can examine the faces and the lives of some or all of these fascinating people: Ernie Vossler, Ralph Plummer, Joe Ezar, Dick Martin, Raymond Gafford, Harry Todd, Rex Baxter, Spec Goldman, Joe Conrad, John Paul Cain, Don Massengale, Dennis Lavender, Harry Cooper, Miller Barber, Buster Reed, Elroy Marti, Tommy Bolt, Dick Crawford, Dave Eichelberger, Gene Towrey, Howard Creel, Ed Hopkins, Jack Munger, Jack Hardin, Howie Johnson, John Bredemus, Bruce Lietzke, Shelley Mayfield, Dolly Brunson, Joe Black, Ray Mangrum, Wes Ellis, Marion Hiskey, L. M. Crannell, Jr., Darrell Royal, Willie Nelson, Joe Jimenez, Dick Metz, and Sandra Palmer. And there are others.

Paul Milosevich conceived the idea for this book. "I was at one of the the first Legends of Golf tournaments [the precursor of today's Senior Professional Golfers' Association Tour] in Austin in 1980," recalls the soft-spoken artist. "I met Jimmy Demaret and Harvey Penick there—that triggered the whole thing." Wouldn't it be great if there was a book of portraits of all these great old golfers, Milosevich thought to himself.

"The idea stayed in my head," he says, until he was approached in 1987 by Judith Keeling of Texas Tech University Press.

"We would like to publish a thirty-year retrospective of your work," Keeling said. Milosevich and

Tech Press subsequently agreed to do three books together: the retrospective *Out of the Ordinary*; *Grass Roots Golf*, a picture book with no text; and *Texas Golf Legends.*

Milosevich grew up on a farm 150 miles northeast of Santa Fe, in Trinidad, Colorado. He was the youngest of the eight children of Matt and Zora Milosevich, who immigrated to the United States in the early 1900s from Ledenice, a small village in the Croatian region of what was then Austria. Paul and his brothers earned spending money by walking the quarter mile from their farm to Trinidad Country Club, where they hired out as caddies. Golf and golfers fascinated the young man.

Milosevich moved to Texas in 1965 and taught art at Odessa College for five years. He spent another five years at Texas Tech in Lubbock before he resigned his tenured postition as an art instructor. He wanted to free-lance. Self-expression and self-determination had become more important than security. "It really wasn't a hard decision," he says.

Along the way, Milosevich developed a pretty good golf game. He played two years of college golf at El Camino Junior College in Los Angeles. A self-described golf nut—he's got a five handicap—Milosevich is a fixture at Willie Nelson's annual tournament (as the official portrait artist of the Songwriter's Hall of Fame in Nashville, Milosevich is friends with lots of country music stars). Like many golfers, the game drives him slightly crazy at times. For example, this admission: "You know how people and animals are supposed to have a fight or flight instinct in a dangerous situation? Well, when I have a tough putt, all I want to do is *run.*"

Milosevich describes his artistic style as impressionistic realism. This means, he says, "sending a telegram instead of writing a novel. I try to give the impression of someone's essence in as few brush strokes as possible." He is fond of quoting the late Diego Rivera, a great artist from Mexico: "The more personal you get, the more universal you get." In his best portraits—Marr, Mangrum, Morris Williams, Jr., Penick, and Adams are my personal favorites, Milosevich maps out so much personality that you feel you know these people—or someone like them. Rivera, I think, would approve.

Paul and I have a lot in common; it's as though we are twin sons of different mothers. For example, we're both from large families (I'm the fifth of seven) and small towns (mine was Hudson, Ohio). We both grew up near a golf course—in my case, two courses, Lake Forest Country Club (where I caddied) and Boston Hills Country Club (where I played). Neither of us likes golf carts; we both wish we could putt.

When Dan Jenkins told Paul and me "when I was a kid, I felt sorry for anyone who wasn't from Fort Worth," I knew just what he meant. Fort Worth was the home of Hogan, Nelson, and Colonial Country Club; two decades later, my hometown, I thought, was the golf capital of the world. Hudson is near Akron, which has Firestone Country Club. There were three major tournaments a year at Firestone back then: The American Golf Classic, The World Series of Golf, and The CBS Golf Classic. My brothers and my friends and I were caddies, gofers, or spectators at these events. Tall cotton for a teenage boy.

Akron was golf mad. The Boys Tournament, a junior event held at Good Park Municipal Golf Course was, believe it or not, televised—live. Other junior and amateur golf tournaments were similarly well covered by radio and newspapers. Many of us who spent hours gazing at Jack Nicklaus's swing at Firestone then tried to reproduce it in the Boys Tournament for the TV cameras of WAKR. I attempted to copy the strokes and mannerisms of Don January, Ken Venturi, Arnold Palmer, and Doug Sanders. The result was a mess.

Not surprisingly, I became a golfer. After four years of college golf (Kent State) and four more as a club and touring professional (Canada, New Zealand, and Florida mini-tours, never The Tour) I was broke and disgusted. I quit. I moved to Texas. But in the ensuing decade, I missed being "in golf." I'm thankful that circumstance has allowed me to return to the game as a writer.

Writing and researching this book, my first, was a pleasure. Some highlights: breakfast with Don January; lunches with Ben Crenshaw, Marilynn Smith, and Homero Blancas; coffee with Dave Marr, Billy Maxwell, Sandra Haynie, Jack Burke, Jr., and Kathy Whitworth; drinks with Dan Jenkins. I played nine holes with Ross Collins, stood inside the gallery ropes at

the Nabisco Championships with Dick Forester, sat alone in a locker room with an honest and unguarded Tom Kite, and sat in the front seat of Don Cherry's Lincoln Continental while he played a tape of his newest album. Fascinating people; successful, determined, proud; and each in his own way and on different levels, legendary.

With only a few exceptions, I met with each of the living people profiled in this book. Lee Trevino and I could never get our schedules synchronized, so when I heard him one morning doing a radio call-in show on KLIF in Dallas, I called in. Lee and I had a cozy little chat about the 1971 U.S. Open, while 25,000 of our close friends listened in. Although Hogan spoke with me on the phone about Linda Craft and Marvin Leonard, he would not agree to a face-to-face discussion about himself. I took no offense; that's Hogan. I passed up subsequent opportunities to approach him at his club, Shady Oaks, when I was visiting my friend Mike Wright, the golf professional there. I rather enjoyed respecting the great man's privacy.

Finally, a word about the stories herein: because, as mentioned, this book pretends to be neither encyclopedia nor biography, I tried in most cases to write about dramatic incidents or illuminating details, to try to find out who each of these legends is rather than recite what he or she did. The quotation at the top of each section is their answer to my one stock question: What are you proudest of?

I hope this book is as fun and rewarding for you to read as it was for me to write.

Curt Sampson

Acknowledgments

The following people deserve my heartfelt thanks: Ben Crenshaw and Tom Kite for contributing the Foreword and Introduction; my older brothers (Nick, Chuck, Matt, and Vince) for introducing me to caddying at the beautiful Trinidad (Colorado) golf course; Roy Dolce, my first golf hero; Ben Hogan, Patty Berg, Harvey Penick, and Gene Torres for continuous inspiration; Dan Jenkins, Jim Murray, and Curt Sampson for their wonderful golf writing; the excellent sports photographers whose work served as reference material; Tony Privett, Judith Keeling, and Marilyn Steinborn at Texas Tech University Press for their invaluable assistance; Pat Maines, Harold Roddy, Darrell Thomas, and James Jester for their technical expertise; Patsie Ross and my family for their love and support; my golfing friends, wherever I stop, who help make playing the game such a treat.

And the beat goes on . . . the winning Texas golf tradition continues, as Texas collegian Justin Leonard captures another major title—the 1992 National Amateur Golf Championship

Paul Milosevich

My sincere thanks to the men and women who allowed me to interview them for this book; to my favorite artist, the DaVinci of the Plains, Paul Milosevich; to Judith Keeling of Texas Tech Press; and to my parents, Robert and Ann. Most of all, I'd like to thank my wife, Cheryl.

Curt Sampson

Introduction

When playing in the pro-ams on the PGA Tour, there seem to be a couple of questions we get asked constantly—questions like "What is your favorite course?" or "What's it like playing in Scotland?" But the most common query we receive has to be "If you could choose any place in the world, where would you live?" I'm sure this comes about because we get to travel so much and see so many wonderful places. And my answer is always simple, "I do get to live anywhere I want and I choose Texas."

Texans are a breed unto themselves. And Texas golfers have made more history than any other breed the world has known. The conditions one must endure just to survive in Texas are well documented. They range from the unrelenting heat of summer to the blue northers that blow in on a second's notice to the winds that just seem to be constantly howling. And then there is the land, that is, the dirt that will be asked to grow the turf of the golf courses. Sometimes it can be so firm that it could be mistaken for a super highway and then after one of those gully washers, so soft a calf could sink up to its shoulders.

These are only a few of the elements any Texan must live with on a daily basis. But the Texas golfer must somehow find a way to maneuver his ball around the course and not let these conditions affect his score—or his sanity. It's easy to see why some of those lush courses of the Northeast seem easy, or the perfect weather of Southern California seems mundane. They are something the Texas golfer sees rarely, if at all.

Do not think for one second it is luck that so many of the world's greatest golfers have been Texans. If you can play well in Texas, the rest of the world is a piece of cake.

Tom Kite

Texas Golf Legends

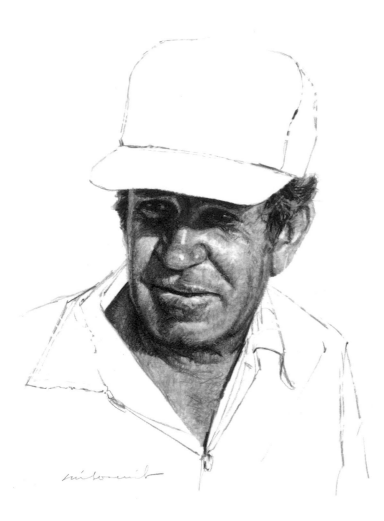

Roland Ray Adams

Born: Roxton
Residence: Lubbock

Proudest of? I don't know. Golf is like work. Like a job.

Roland Adams, in plumber's clothes and gimme cap, played a round of golf in Odessa in 1959 with smooth-talking, slick-dressing Titanic Thompson. The gambler and the geek. Thompson was impressed—not with Adams's attire, of course, but with his golf game, which was very, very good. This is just the kind of wolf in plumber's clothing I can make some money with, thought Thompson.

"I'd like to take you out on the trail with me, son," said Thompson. "But that draw of yours would scare these yokels into not betting. Can't you play a slice?"

Adams teed up a ball and aimed it dead left. "I started that ball out over Highway 80 and sliced it back into the middle of the fairway," recalls Adams delightedly. "I looked back and Ti's eyes were as big as silver dollars!"

The on-command left-to-right curveball was just for fun; Adams wouldn't go with Thompson. His

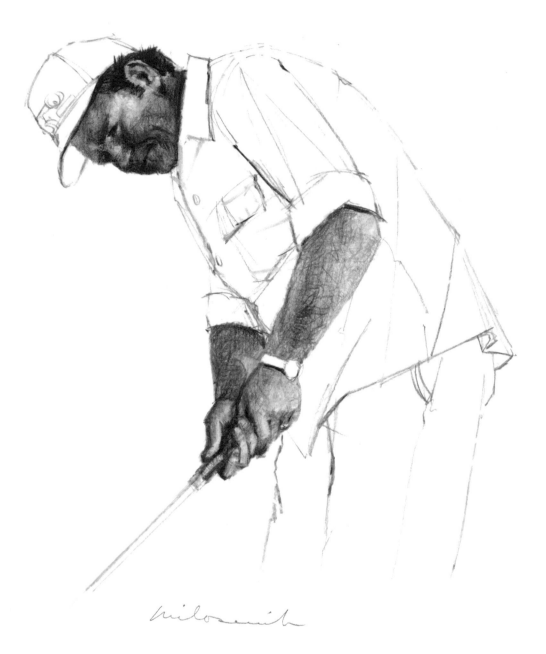

reluctance to travel has caused him to remain a lower-case, local legend intead of the nationally prominent golfer he could have been. He sticks around Lubbock because he's a family man with seven children, because he's got a job, and because he is just not comfortable in the private country club settings you find at the big events. Like Lee Trevino, Adams changes into his golf shoes in the parking lot. He has no use for a carpeted locker room with seven kinds of aftershave and five brands of hair tonic, thank you very much.

Former Lubbock mayor Dirk West tells the story—which Adams denies—about the time some Lubbock businessmen paid Adams's way to the 1965 U.S. Open qualifier at swank Cherry Hills Country Club in Denver. After a few days, one of the sponsors traveled up to check on his investment, only to find that Adams had not yet checked in with the tournament staff. Eventually, the man spotted Adams's pink Cadillac in a remote, shady corner of the parking lot, down near the maintenance shed. Inside, sound asleep on the front seat, was Adams. The back seat was full of golf balls, several thousand of them. The puzzled man nudged Adams awake. He was *damp*. The groggy Adams sat up and said no, he hadn't rented a hotel room and no, he hadn't played a practice round. Instead, he was sleeping during the day and spending each night in the Cherry Hills water hazards, and was finding the golf ball fishing quite good.

Adams is a frustrating man to those, like the businessmen, who don't understand him. It's just no use to expect him to win or even qualify for a U.S. Open, even though he has—or had—the game for it. The atmosphere is wrong. But if you're a hot-shot player on the Texas Tech golf team, just forget about challenging the leathery little man on the golf course.

"We just got *tired* of Roland beating us all the time," says former Tech ace John Shackleford, who owns the course record of sixty-three at Onion Creek in Austin. "I was supposed to play a match with him one time, and I heard he was in an all-night card game. I got the address and picked him up at daybreak. This was the one time I thought I had him. Well, hung over and sleepless, he whipped me. I couldn't believe it."

Adams nods at the retelling of this story. "I could play good after stayin' up all night drinkin' and playin' poker," he says. "But we had to play in the morning. I was no good in the afternoon. Once in Hereford, six pros and I played in the morning after an all-night game. They all hit it in the water about twenty-five yards in front of the first tee. I shot sixty-six that morning."

On another occasion, Adams and an accomplice were driving through Olney and noticed a golf course by the highway. The inevitable happened; Adams and the friend stopped the car, got themselves into as many money matches as they could, and won every bet. Adams shot sixty-four, five shots below the course record. "Play gin?" asked one of the victims, the time-honored question of the losing side. "We left there with about twelve hundred dollars in a paper sack," grins the gap-toothed Adams. "We counted it all the way back to Lubbock."

Adams has won countless tournaments on the West Texas "barbecue circuit," including eleven of the fifteen he played in 1959. He has broken sixty for eighteen holes at Pine Hills (now Elm Grove) in Lubbock three times. How does he hole a putt he really has to make? " I never had a putt I *had* to make," he says.

Homero Blancas

Born: Houston
Residence: Tucson, AZ

*I'm proud to have graduated from college, and I'm
proud of my marriage and family.*

"I started the final round birdie-eagle-birdie-birdie,
then missed a short putt on the fifth hole." Homero
Blancas is recalling the day in 1961 in Longview
when he shot sixty-two and fifty-five in the final two
rounds of the Premier Invitational. The other diners
at Blancas's table listen in wonder, their cheeseburg-
ers and fries forgotten. You shot *fifty-five*, Homero?
Wasn't that some kind of record? And you missed a
short putt?

"And I missed another little one, four or five feet,
on number eleven. Some kid slammed on his bike
brakes just as I was hitting the putt," Blancas says,
casually. "It was a small golf course [it no longer ex-
ists; but it was regulation length and par seventy]. I
just got in 'the zone.' Just one of those things." Blancas
spreads mayonnaise and mustard on his burger and
takes a bite. He's the only one eating. You mean you

could have shot fifty-three, Homero? *Fifty-three!* Why haven't we heard about this before?

Blancas shrugs. "I've always been a little bit obscure. But I like it like that."

No one appreciated Blancas's obscurity more than University of Houston golf coach Dave Williams. "We got pretty lucky on Homero," Williams says. "Not too many people were interested in him, because he didn't have the money to play in many junior or amateur tournaments." But Blancas always had a good place to play. His father was greenkeeper at River Oaks, one of Houston's best clubs. Little Homero played the course very early or very late and caddied in between. "Because I was little, I used to caddy for the college golfers who played at River Oaks—they had small bags. I learned to play by observing them. I was never exposed to high handicappers."

So the best young player no one—including Williams—had ever heard of chose to play at Houston, mostly because it was close to home. What a windfall for Williams: Blancas played on two National Collegiate Athletic Association (NCAA) championship teams, was All-American twice, and shot that sixty-two and fifty-five in the summer between his junior and senior years. "One of the best players we ever had," says Williams.

Blancas played an NCAA championship practice round in 1961 with another college junior, Jack Nicklaus. "Are you turning pro this year?" asked Nicklaus. "I am, in January. You should, too. You're good enough."

Blancas was getting the same advice from a number of people. He was tempted. "But Jackson Bradley, the pro at River Oaks, told me I shouldn't quit school early; 'You got to finish,' he said. I'm glad I listened to him."

Blancas is an extremely low-key person who becomes animated and forceful on two subjects: the value of an education—and how to hit a golf ball. He is particularly profound on the latter subject. Two of his best tips:

"Don't practice three- or four- or five-foot putts. You'll miss too many of them. The whole object of practice is visualization. So practice one-footers, a putt you make every time. Then you'll start expecting to make longer putts.

"How do you hit the ball? With the club head. How do you hit it further? Increase club head speed. How do you increase club head speed? Wrists. Not body. Wrists."

Homero Blancas won four PGA tour titles. He shot sixty-one in the second round of the 1972 Phoenix Open, which he won. He was 1965 Rookie of the Year and played on the 1973 Ryder Cup team.

John Joseph Burke, Jr.

Born: Fort Worth
Residence: Houston

The biggest thing we did was stage the U.S. Open in 1969. And in thirty years at this club, we've never assessed the members a dime.

Jack Burke, Jr., is restless. Physically and intellectually, he can't sit still. At age sixty-nine, he is owner and day-to-day operator of Champions Golf Club in Houston, which he founded with the late Jimmy Demaret. He has started a family with his second wife, Robin; they have a daughter, Meghan. And when this 1956 Masters and PGA champion, World War II marine, and father of six wants to relax, he goes to the gym for instruction in tae kwon do.

The martial arts are his hobby.

Burke is a handsome man with a full head of gray hair, penetrating blue eyes, and a direct manner. He is opinionated, articulate, sometimes profound. Here then, is Burke . . .

On survival: "My father was the golf professional at River Oaks Country Club [in Houston], and I

started out there in the caddy yard. If you can survive the caddy yard, you can survive anything.

"This was during the Depression, so lots of guys showed up to caddy.

"They'd have a drawing. Only the people who drew the lowest numbers were likely to get a bag to carry. So you wanted to gamble—cards or dice—with a guy with a low number, because he could pay if you won.

"Gambling was the only way to make money at golf. I played because I gambled—and won."

On winning the Masters: "I never felt I was going to win, even when I made the last putt. Pressure? The pressure that day was to not shoot a hundred. There was a fifty-mile-an-hour wind. On the fourth hole, a par three, I hit a driver and a nine iron."

On winning the PGA Championship: "I played Leon Pounders in the first round [the PGA was a match play tournament until 1958]. 'Who's Pounders? Man, you got it easy,' people said. Well, his name might just as well have been Hogan. I shot thirty-two on the front nine—and we were even." Burke beat Ted Kroll in the finals, three and two.

On Jimmy Demaret, who worked for his father in the River Oaks pro shop, introduced him to life on the tour, became his business partner, and died in 1987: "I miss him. I was with him all my life; he was my closest friend. Jimmy would play golf for anything, anytime."

On golf in Texas: "The game is only seventy or eighty years old in Texas, and a lot of people here don't understand it is a game controlled by a severe set of rules. You observe all the rules with a deck of cards, don't you? I believe that if you move the ball [improve your lie in the rough or the fairway] you should be asked to leave the club.

"Society wants to *subdue* this game—with glass shafts, or a long putter—they see golf as just a grassed-in sign board, a marketing tool. What about coming out to the golf course to play a game and observe the rules?

"That's why we made Champions for golfers. We have 229 members with single-digit handicaps. Fifty-five members have five handicaps or under."

Burke digs in a drawer of his big desk and hands a visitor a five-page copy of his favorite quotations.

Plato, Rousseau, Aristotle, Confucius, and other philosophers make insightful comments on spiritual and aesthetic value, the role of leisure and play, education, and psychology. Burke clearly relishes such distilled wisdom. One quotation, from August Hecksher, seems to capture Burke, the gambler, Marine sargeant, golf champion, and entrepreneur: "Happiness is the exercise of the individual's powers along lines that he deems significant."

Jack Burke, Jr., won four tournaments in a row in 1952, the second longest consecutive win streak in PGA tour history. In twenty years on the tour, he had seventeen wins, including the Masters and the PGA in 1956 and four Ryder Cup appearances (he was player/captain in 1957). Burke won the Vardon Trophy in 1956 and is a member of the PGA Hall of Fame. He was PGA Player of the Year in 1956.

John Joseph Burke, Sr.

Born: Philadelphia, PA, 1888
Died: Houston, 1943

First would have to be his family—he had eight kids. Second was being runner-up in the Open at Inverness. And I know he enjoyed winning the first PGA seniors tournament in Florida in about 1939. Jack Burke, Jr.

From the *Jimmy Demaret Golf-To-Music Lessons* "A Chat With Jimmy Demaret":

"Jack Burke, Sr., a man of fundamental conviction about everything in his life, was the same way about the golf swing.

"There were things you did when you swung a golf club, and there were things you didn't do. You did all of the fundamental things, and you did nothing else. First you learned the fundamentals then you made sure you understood each and its relationship to the other. If you lived a hundred years, I was told, nothing you could do, regarding your study of the golf swing, would take you beyond the fundamentals.

"My stay as assistant to Jack Burke, Sr., the head golf professional at River Oaks [in Houston] was a

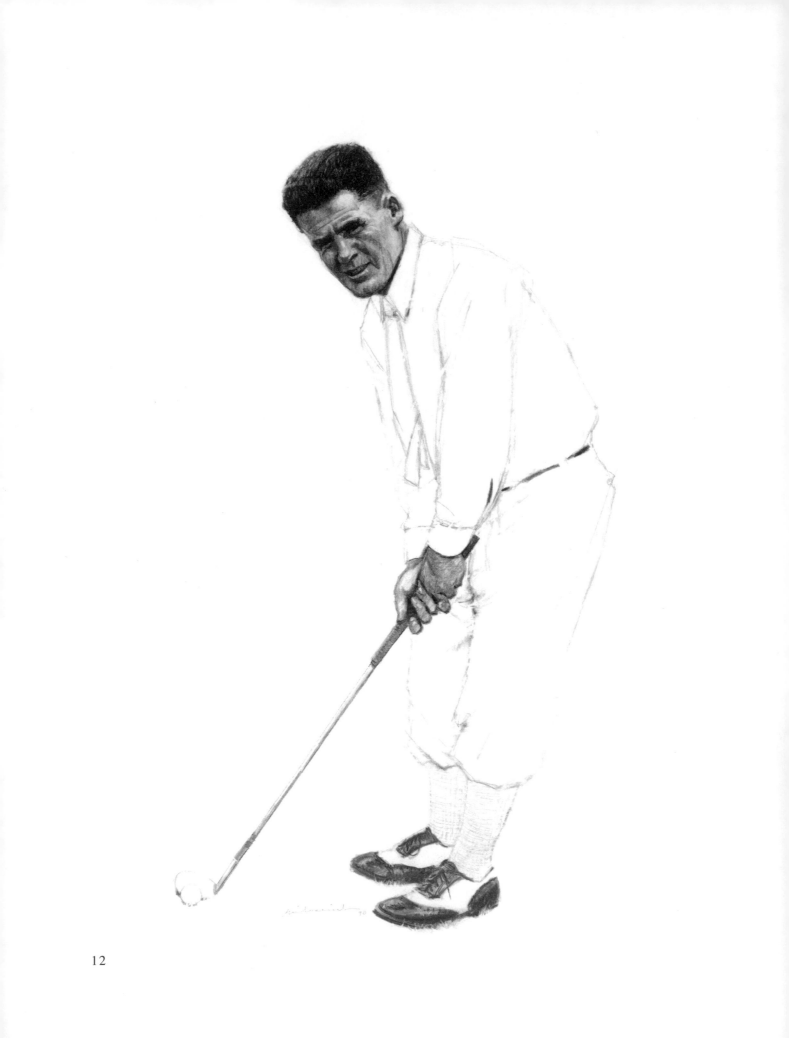

12

disciplined one. For example, he once told me I could play all the golf I wanted to play before six in the morning."

From the *Houston Post* obituary of Jack Burke, Sr., Wednesday, February 3, 1943:

"Sportsmen and golfers in every section of the nation were shocked and deeply grieved by the unexpected death of John Joseph (Jack) Burke, 54 . . . the only professional to serve at River Oaks Country Club since it was opened 18 years ago.

"Final plans were held in abeyance pending the arrival of his oldest son, Pvt. Jack Burke, Jr., of the United States Marines, from San Diego . . .

"The stubby, wrinkled Burke, remarkably well preserved for his years, was an outstanding golfer two decades ago and in recent years was recognized as one of the game's greatest teachers . . .

"Jimmy Demaret, finest golfer ever to be developed in Houston, gave most of the credit for his success to Burke. 'I have never known anyone with more friends,' Demaret said Tuesday. 'I am so shocked . . . I hardly know what to say.'

"All of Mr. Burke's (four) sons are promising golfers and his eldest son, Jack, was professional at the Galveston Country Club before joining the Marines."

Jack Burke, Jr., on his father:

"My father was from Philadelphia, a city which produced some really unique people. Back then, if you were a good teacher, you got a good job. Some rich oil men heard how good my father was and got him to come down here [to Houston, from St. Paul, Minnesota] to be the professional at River Oaks.

"Yes, he was a helluva good player, too. He almost won the U.S. Open, he won the St. Paul Open seven times. He won the Los Angeles Open and the Texas PGA. And he beat Demaret in the Texas PGA when he was forty-eight.

"How did he teach? 'My only system is no system,' he used to say. Only a lazy person has a system. He gave me the two swing thoughts I used my whole career: point the clubhead at the target at the top of the backswing, then wrap the club around your neck on the follow through. He didn't give you thoughts that weren't forever. The dissected swing is bullshit.

"To teach people to release their hands at impact, he'd have them take the club back, come down . . . and throw it. I'd have to go pick those clubs up.

"Jack Grout [and many other teaching professionals] used to take lessons from my father." Grout would later apply Burke's fundamentals in his instruction of a promising junior golfer named Jack Nicklaus.

Jack Burke finished second in the 1920 U.S. Open at Inverness by one shot; he qualified for the Ryder Cup that year, but declined his spot on the team. His two most accomplished students were his assistant, Demaret, and his son, Jack.

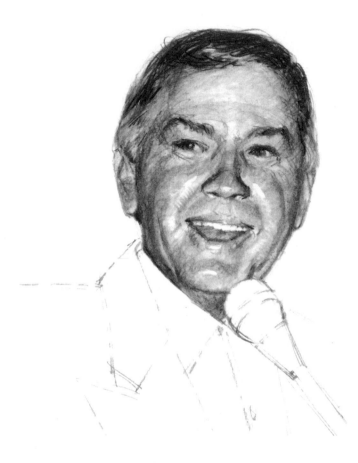

Donald Ross Cherry

Born: Wichita Falls
Residence: Las Vegas, NV

*I'm proudest of being selected to the Walker Cup.
All the rest of the stuff I did, I screwed up.*

A tweedy Scotsman pulls two shillings out of his pocket and buys an official programme for the 1955 Walker Cup match at The Old Course at St. Andrews, Scotland. Who to watch? The man opens the booklet to see who the Yanks have brought this year. Playing for the U.S. in the first foursomes (alternate shot) match, he sees, will be Mr. E. Harvie Ward of Tarboro, North Carolina, and Mr. Don Cherry of Wichita Falls, Texas. Cherry, the man reads, "[is] a professional singer of popular songs, has made many gramophone records and he appears on radio and television networks and at theatres and night clubs throughout America." I say, the Scotsman says to himself, didn't I hear Don Cherry on the radio this morning? He's the bloke who sings "Band of Gold." The man decides to join the throng watching Cherry.

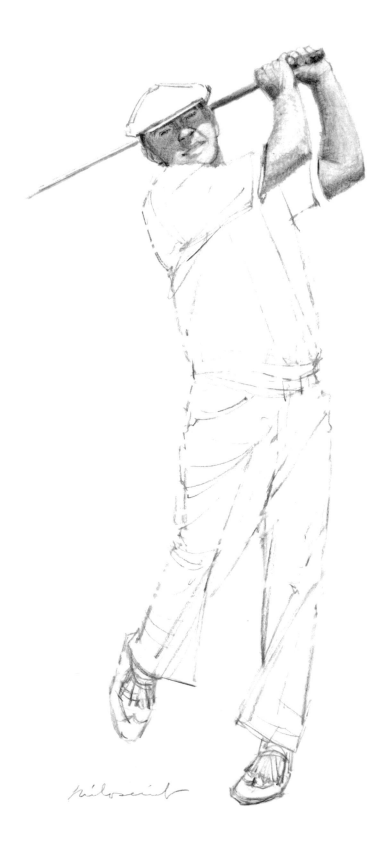

He sees a thrilling match. Joe Carr and Ronnie White of Great Britain take a one-up lead after Cherry misses a short putt on the fifteenth, the thirty-third hole of the thirty-six hole match. Then Cherry drives into the left nostril of the Principal's Nose, the infamous set of steep-sided fairway bunkers on the sixteenth hole. Ward wades into the pit, thrashes at the ball, then climbs back out. The ball remains. Cherry repeats the procedure and barely manages to move the ball out of the hazard. Ward's subsequent shot to the green is not a good one; the Americans lie four, seventy-five feet from the hole. The Brits lie two, about thirty feet closer.

"Where you gonna play it?" Ward asks his partner.

Cherry gives Ward a look. "I'm just gonna hit it," he says, and does. The ball goes in; the crowd roars. The unnerved British team three-putts to halve the hole.

The Americans birdie the seventeenth, the Road Hole, one of the toughest holes in golf, and the match is even. The British side three-putts again on the eighteenth and final green, to give Ward and Cherry an unlikely, unforgettable win.

The next day the two teams line up on the steps of the massive stone clubhouse of the Royal and Ancient Golf Club for the closing ceremony. Lord Brabazon, concluding his remarks to the crowd of ten thousand, says "At last we have a golfer who can sing." There is hearty laughter at Brabazon's reference to Bing Crosby, who had played in the British Amateur at St. Andrews the year before. "Mr. Don Cherry," his lordship says, "would you honor us with a song?"

Cherry remembers the moment vividly. "The wind stopped. There was utter silence. I did 'I Believe'. They gave me the biggest ovation of my life."

There is an interesting complexity to Don Cherry that goes beyond his success in the disparate fields of golf and singing. He is a family man but has been married—and divorced—four times. His closest friends—Dean Martin, Phil Harris, Jimmy Demaret, Bobby Layne, Mickey Mantle—were all noted imbibers, but Cherry has never smoked or drank. He is a self-described introvert, yet has made his living on the stage. And despite his Las Vegas cool/West Texas friendly personality, Cherry had a temper on the golf course that was devastating.

"I actually took the game of golf and got the minimum out of the maximum," Cherry says. "I could have really done something with golf. I did the same thing with singing."

Cherry is given to such introspective comments lately because he is working on a book, the story of his life. He's made hours of tapes, recalling, for example, his marriages (the first was to Miss America of 1956; the second lasted less than a day; the third was to Miss Nevada of 1967) and the times Demaret led groups of nightclubbing golf pros in organized disruption of his performance.

Cherry has asked his friends for contributions to the book. Jack Nicklaus sent a witty one-page letter. Arnold Palmer sent a paragraph. Darrell Royal's contribution seems brutally honest; Jack Burke's missive is enigmatic; and Larry Gatlin's and Mickey Mantle's notes are funny.

The best guest writer is Willie Nelson, with whom Cherry is recording an album. Nelson's R-rated letter includes a possible song lyric ("It was only an old Titleist 2 / But it did what it was intended to do . . . ") and concludes "P.S. And he can sing and he can play golf. What else is there?"

Don Cherry won "about eighty" amateur tournaments, including the 1953 Canadian Amateur and played on two Walker Cup teams. He finished ninth in the 1960 U.S. Open. Cherry played the tour from 1952 (he turned pro in 1962) until 1978.

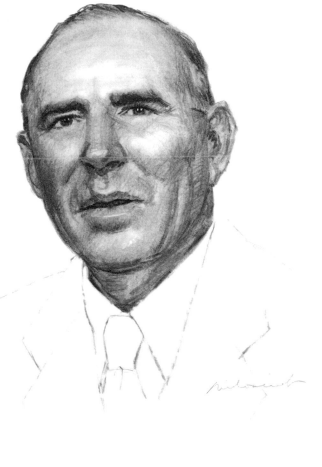

Fred Cobb

Born: Antelope, 1899
Died: Denton, 1954

Just guessing . . . but the first year North Texas won the NCAA, the team was referred to in one story as 'something called North Texas State won the team competition.' That burned his ass real well, the nonpublicity the team received. The next year we won every tournament and every match, including the NCAA I think that made his heart content. Don January

Most players on today's pro tours learned their craft in professional golf's minor leagues—college. It hasn't always been that way; college golf was once a puny, insignificant thing, an underfunded, under-publicized enterprise that rarely—if ever—produced professional golfers. Private northeastern schools like Yale usually won the NCAA championship; current powers like the University of Texas and Oklahoma State either didn't play or didn't take it seriously. Golf then was like lacrosse or rugby now. But Fred Cobb changed all that.

18

Cobb was a football coach, physical education instructor, and unpaid golf coach at North Texas State University in Denton. As World War II ended and collegiate athletic competition resumed, he decided to make NTSU a national golf power. Cobb was inspired by his friend and neighbor, Byron Nelson.

"Fred would call me and say 'My boys are practicing. Can you come up?'" Nelson recalls. "I didn't give them lessons. I'd just watch and they'd ask me questions. And they used my book, *Winning Golf*.

"Fred was very easy going and quiet. But he had the ability to instill confidence in a team. He knew how to pick boys and how to handle them. Everybody loved him."

Cobb was among the first coaches to understand the corollary between recruiting good players and winning. But the best NTSU golfers sometimes rode the bench. "He played the guys not necessarily playing the best, but the ones who were making grades and taking an interest, working on their games," says Billy Maxwell, one of the best college golfers of that or any era. "Fred Cobb was the greatest, fairest golf coach—person, really. He was every boy's dream. A real coach."

Maxwell, Joe Conrad, and Don January formed the core of the best golf team in the country. "We were the guys no one else wanted," January says. Maxwell had gone to Southern Methodist University for a semester; Conrad went to Lousiana State University and didn't like it; and January bounced from Oklahoma A&M to Arlington Junior College to SMU. Cobb made the three itinerant teenage golfers feel welcome.

"Scholarships were illegal, so Fred got us jobs in the physical education department for room and board, plus ten dollars a month laundry money," remembers January. "None of us had any money.

"We'd go out to practice on our golf course, which was never in very good shape, and Fred would tell us to play the ball down. 'Play it down? Hell, Coach, there's no grass out there!' But when you finally got on a course in good condition, golf was easy. Man, you felt like you could hit a driver off the fairway.

"Fred never tried to teach us golf, but he coached us as individuals. He knew each of us required different handling. He knew one guy might need a sledgehammer upside the head and another guy might need a pat on the ass."

One day in 1953, the University of Houston golf team drove up to Denton for a match. Dave Williams, the new Houston coach, walked eagerly from the parking lot into the clubhouse of the homely nine-hole NTSU course. Big day today, fellas, Williams had been telling his team on the long drive from Houston. Today we play the best.

"But no one was there," Williams recalls. "So I told this young man that we were from the University of Houston and were supposed to have a match. 'Coach Cobb took the top six players to a tournament in Shreveport,' he said. 'Let me go down to the dorm and get some guys.' Oh boy, I thought, we're gonna beat the national champs.

"North Texas beat us 6-0."

Fred Cobb's golf teams won four consecutive NCAA golf championships, from 1949-1953. Cobb died of a heart attack in 1954.

Ross Thomas Collins

Born: Mingus
Residence: Kerrville

Being named PGA Professional of the Year was an opportunity to represent a lot of guys who do a great job. It was a great honor.

"I came from a real poor family," says Ross Collins, a distinguished, successful-looking man of seventy, whose mouth tends to form itself into a smile. He grew up in a tiny "shotgun" house in the oil field camps in and around Eliasville, a dot on the map west of Mineral Wells. Collins's father was an oil-company gangpusher (foreman), a job that supplied barely adequate housing and low wages in return for near-constant physical work. One day the company fired about fifty employees, including Jesse Curtis Collins; they all had been hired at about the same time nineteen and a half years earlier. They would have qualified for company pensions after twenty years.

Near the Eliasville camp was a dirt tennis court, a basketball hoop without a net, a dirt baseball diamond, and a nine-hole sand-green golf course. Young Ross used all the facilities in the tireless fashion of lonely children and became particularly adept at baseball and tennis. In 1940, the year after he graduated from high school, the Brooklyn Dodgers offered him a contract to play for their Triple A minor league baseball team in Rochester, New York. Collins turned it down. He preferred to continue his freshman year at North Texas State; he had a tennis "scholarship," which, he says, "entitled you to work."

Collins didn't play much golf back then on the greens of sand and cottonseed hulls around Eliasville and Breckenridge. There was an equipment problem. Collins is left-handed, and left-handed golf clubs were rare.

He joined the Navy Air Corps in 1942. During his training, he played baseball for the base team in Delmonico, California. "The manager was a scout for the

20

Brooklyn Dodgers, the same team that had offered me a professional contract," Collins recalls. "He offered to get me stateside service in lighter-than-air [blimps], but I said no. I wanted to fight the war."

He took aerobatics at the University of Texas, got his wings in 1943 in Corpus Christi, then was shipped to Chicago to practice landings onto the deck of a converted freighter in Lake Michigan. Collins was a pilot; his plane was the Curtiss SB 2C Scout Bomber, a tiny two-man aircraft. From the rear seat, a gunner would fire a .30-caliber machine gun on a swivel. In the front seat, Collins would push the plane into ascents and descents steeper and more terrifying than any roller coaster ride. The SB 2C was a dive bomber.

Collins was assigned to the aircraft carrier USS Bennington. He flew thirty combat missions over Japan, won the Navy Cross and three Air Medals—and doesn't like to talk about it. "I've never talked about the war much, except with my wife and children," says Collins. "I don't believe in medals a lot. A lot of people who did a helluva lot more than me didn't get them. I don't think you should get a medal for killing people.

"Some guys would just put the nose down and drop the bomb, well, you're not going to hit anything that way. You had to go down to twelve hundred feet to hit a target. I always did. [Even] small-arms fire could get you down there.

"I'm not afraid of dying. Never have been. I made my peace with the Lord at age twenty-one. The friends I had in the war who were afraid to die were the ones who lost their lives."

Collins was a thirty-two-year-old left-handed amateur golf champion and the basketball/tennis/baseball/golf coach at Arkansas A&M when he decided "coaching is not the way to make a living." About a year before he took his first job as an assistant to Graham Ross at Dallas Athletic Club (DAC), Collins bought a set of right-handed clubs. "There was still a slight stigma attached to being left-handed, so I thought I better learn to play right-handed," he says. "I worked on it for a year. I could shoot par occasionally, but I saw it would take five or six years to play as well [right] as I already could [left]." He remained a lefty.

Collins was happy to discover that teaching right-handed golfers was no problem—"I just stood in front of my student and swung with him, like a mirror." Another aspect of his new profession appalled him, however. "The first PGA meetings I went to," recalls Collins, "most everyone got drunk. I didn't like that image—golf pros as good drinkers and gin players—for them or for myself."

He did something about it. In 1960—Collins was now a head professional at Lakewood Country Club in Dallas—he began a series of educational seminars for his brother pros. He got golf legends like his close friends Byron Nelson and Ben Hogan ("he is an outstanding speaker") to address the awed study groups. And he let it be known that no one in his employ would ever drink, gamble, or play cards while at work.

Soon, every good club in Texas looking for a golf pro wanted one trained by Ross Collins. Collins alumni at some of the best clubs in the state are Bob Elliot, Dennis Ewing, Coy Sevier, Bob Smith, Jerry Smith, and Steve Wheelis. One other group—Ross, Fred, and Cary Collins, the sons of Ross Collins—are also Class A PGA professionals. "No, I never considered another career," says Cary, the youngest son and the head professional at Pleasant Valley Country Club in Little Rock, Arkansas. "I got to see the golf business from the positive side. Dad was such a good role model."

Ross Collins earned bachelor of science and masters degrees at North Texas while playing on seven conference championship teams in tennis, basketball, and golf. He won the Arkansas Amateur three times, the National Left-Handed Amateur twice, the National Left-Handed Open twice, and the Arkansas Open once. He was a PGA Section president three years and was Section Senior champion three times. He is a member of the Texas Golf Hall of Fame.

Billy Charles Coody

Born: Stamford
Residence: Abilene

Ask any player who's been fortunate enough to win a tournament like the Masters . . . he'll be very proud of that.

Charles Coody was about to win the 1969 Masters. Journalist Dick Schaap describes the moment in his book *The Masters:* " . . . coming off a birdie on the fifteenth hole, Charlie Coody was one stroke in front of everyone else. 'Just three pars,' he told himself, 'on these last three holes, and you can win.'

"On the sixteenth hole . . . Coody hesitated. He thought of hitting a hard six-iron or a smooth five. He decided against risking a weak shot that might splash in the water guarding the green. He used a five-iron and hooked the ball off the green.

"Coody took a bogey on sixteen, a bogey on seventeen and a bogey on eighteen and finished two strokes behind George Archer. 'I had it won,' Coody said afterward, 'if I'd just gotten those three little pars.'"

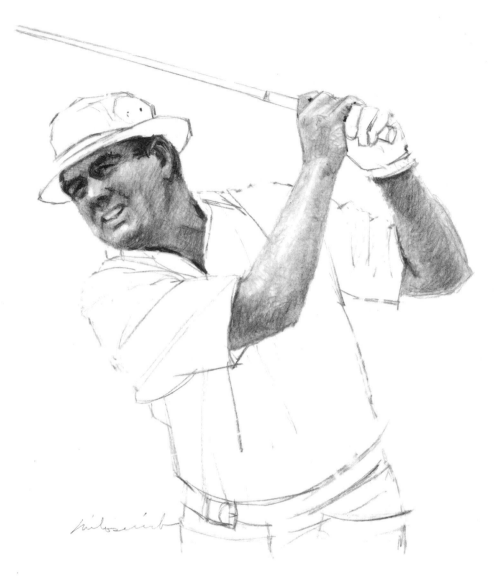

24

Again in 1970, Coody was about to win the Masters. He shot seventy and seventy-four, then a brilliant sixty-seven, the low round of the day, to move within three shots of tournament leader Billy Casper, with one round to play. But again he faltered in the stretch. He shot seventy-seven and finished twelfth.

"Sure, I was disappointed," Coody recalls. "I'm not a Palmer or a Nicklaus. I knew there were not going to be that many opportunities for me to win at Augusta."

Coody had been a typical sports-loving kid in his tiny hometown of Stamford, north of Abilene, until he was stricken with nonparalytic polio. "I remember spending my thirteenth birthday in the hospital," says Coody. "The doctor said 'no contact sports for now, not even basketball.' My father said that I'd swung a golf club a few times, would that be OK? 'Golf's great,' the doctor said." Little Charlie made the town's nine-hole golf course his new home.

He attended Texas Christian University—"where I crammed a four-year course into five"—because the Horned Frogs would allow him to play his first love, basketball (Coody was All-State his senior year at Stamford High) as well as golf. He dropped hoops after a year. After TCU and a three-year hitch in the Air Force, Coody turned pro.

Augusta National Golf Club in April, Masters time, is a hilly, green, fragrant cathedral in the pines. Dave Marr once said he got the feeling that if he didn't play well at Augusta, he wouldn't go to heaven. But in 1971, Charles Coody was past thinking such reverent thoughts. He tried to forget about the history of the place and his history there; he ignored the blooming dogwoods and azaleas. He just wanted to win. It was under his skin.

Even when he led the field with a sixty-six in the first round, no one said Charles Coody is about to win the Masters. People merely mentioned to each other that this fella Coody seems to play well here before he loses, and wonder if Nicklaus, Watson, Weiskopf, or Johnny Miller is going to win?

The popular opinion of Coody's chances seemed to be confirmed when he had a three-putt bogey on the fourteenth hole of the final round to fall two shots behind Miller. But Coody birdied fifteen while Miller bogied sixteen; they were tied.

On sixteen, a par three with lots of water, sand, people, TV cameras, and pressure, Coody hit a beauty. His six-iron shot stopped ten feet from the hole in the back right of the green. "Then," he remembers, "it was just one of those things. I knew I was gonna make that putt. It was like there was a trench dug between my ball and the hole. I had to force myself to take my time."

Coody, a methodical player, took his usual two smooth, wristy practice strokes with his old, black-headed Spalding HB putter. Then, as always, he tugged his left pant leg with his left hand. CBS television commentator Henry Longhurst murmured: "Coody strokes it . . . it's in! Beautifully holed. Coody leads by one."

Two holes and twenty minutes later, Charles Coody had, at last, won the Masters.

Coody won the 1971 World Series of Golf (then an unofficial event) and made the 1971 Ryder Cup team after he won the Masters. He had two other PGA tour wins, qualified for the 1960 and 1961 U.S. Opens as an amateur, and advanced to the semifinals of the 1962 U.S. Amateur. As of this writing, he has won five tournaments and more than two million dollars on the Senior PGA Tour.

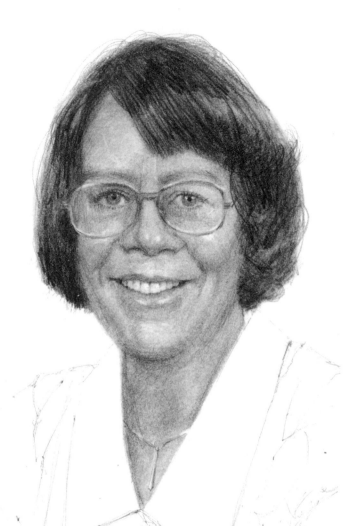

Linda Louise Craft

Born: Fort Worth
Residence: Jacksboro

I'm proud that I stayed with golf.

Linda Craft hit her first golf ball at age twenty-six. Twenty-six months later, she found herself on the first tee at the Amarillo Ladies Open. Linda, meet your playing partners in your first LPGA tournament: Kathy Whitworth and Louise Suggs. These other folks are what is known as a gallery.

"My knees were knocking," Craft says. "But I'm proud I was able to even be in professional golf. I went against everyone and everything: my parents, friends, skill, experience."

Such optimism in the face of adversity is Craft's greatest strength. She lacked youth and amateur tournament experience, yet she was a moderate success in her five years on the tour. She had little money and less teaching background when she started a golf instruction school with Penny Zavichas in 1968, but today Craft-Zavichas is the second oldest golf school in the country. Craft became an accomplished player and teacher armed only with

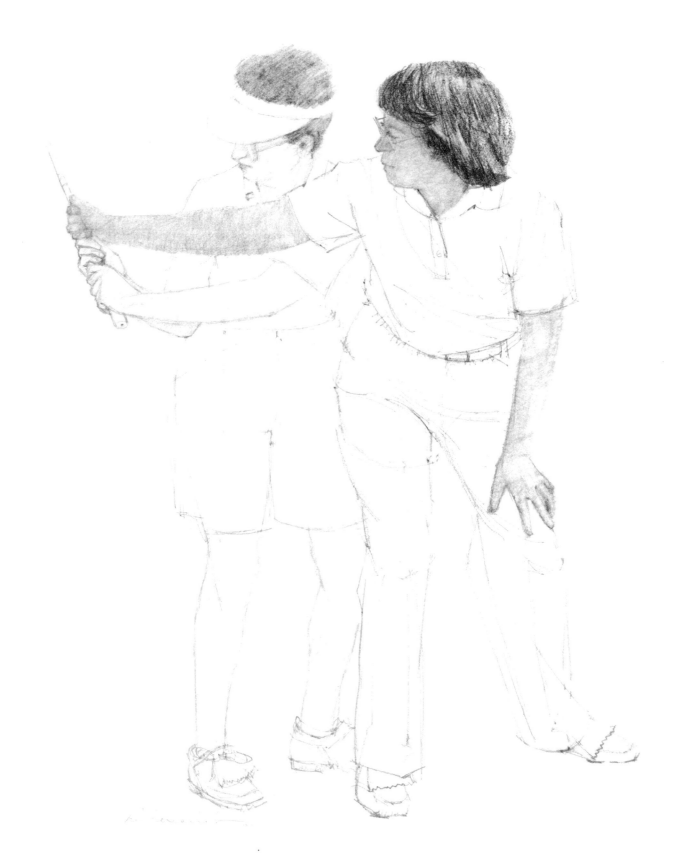

27

persistence, enthusiasm, and good health. Then she lost her health.

"I was in Scottsdale, Arizona, in '74 when I noticed that a birthmark mole on my left leg was changing," Craft says. She had it checked out. "Does this look OK, Doc?" asked Craft.

"No, it doesn't, Linda," the physician said flatly. "You've got cancer."

Craft was stunned. "I'd already been doing volunteer work for the American Cancer Society," she recalls. "Then I got it." In quick succession, Craft felt fear, anger ("I took such good care of myself; my body let me down"), then, typically, determination. She skipped altogether the depression and despair very sick people usually feel. And despite being in and out of hospitals for the next thirteen years—she had eleven operations—"I never thought about withdrawing. I got stronger with each surgery. I talk to my (anticancer) pills. Of course, I do get real scared every three months, just before my checkup."

After her illness was diagnosed and her treatment began, Craft resumed her usual activities—with a vengeance. She became a top fund raiser for the Cancer Society. She built a collection of golf-related items that is one of the best and most valuable in the country. And she continued to teach and think about golf. Her conclusion after twenty-five years of giving group lessons: "The master weakness of all golfers is proper leg action. People just won't shift their weight. You do it when you play tennis or ping pong, or when you walk. Why not in the golf swing?"

Linda Craft was the 1987 LPGA Teacher of the Year. She also won the 1990 Ben Hogan Award, given by the Golf Writers Association of America to the golfer who makes the most notable comeback from illness or injury. "Winning the Hogan Award is the highlight of my struggle," says Craft.

Ben Daniel Crenshaw

Born: Austin
Residence: Austin

I'm so proud of my family.

Like King Arthur's sword and B.B. King's guitar, Ben Crenshaw's putter has a name. Arthur had Excalibur, and King plays the blues on Lucille. Crenshaw putts with Little Ben.

The most famous golf club of the day is a 35-inch-long Wilson 8802 with a light blue grip wrapped with white fabric tape. At times it seems as if this inanimate piece of rubber and steel is magic, that it can hole improbable putts by itself, that Crenshaw need only hold on, then pick the ball out of the hole. Charlie Crenshaw, Sr., remembers when he gave his teenage son the club in about 1965: "It was just a putter in Harvey Penick's pro shop. Ben felt it and waggled it around for a while. 'Dad, I'd like to have it,' he said, so I bought it for him." It cost less than twenty dollars. "That club's been the best provider in the family," Crenshaw, Sr., concludes with a smile.

So great is Crenshaw's reputation as a putter—Curtis Strange recently proclaimed him "the best

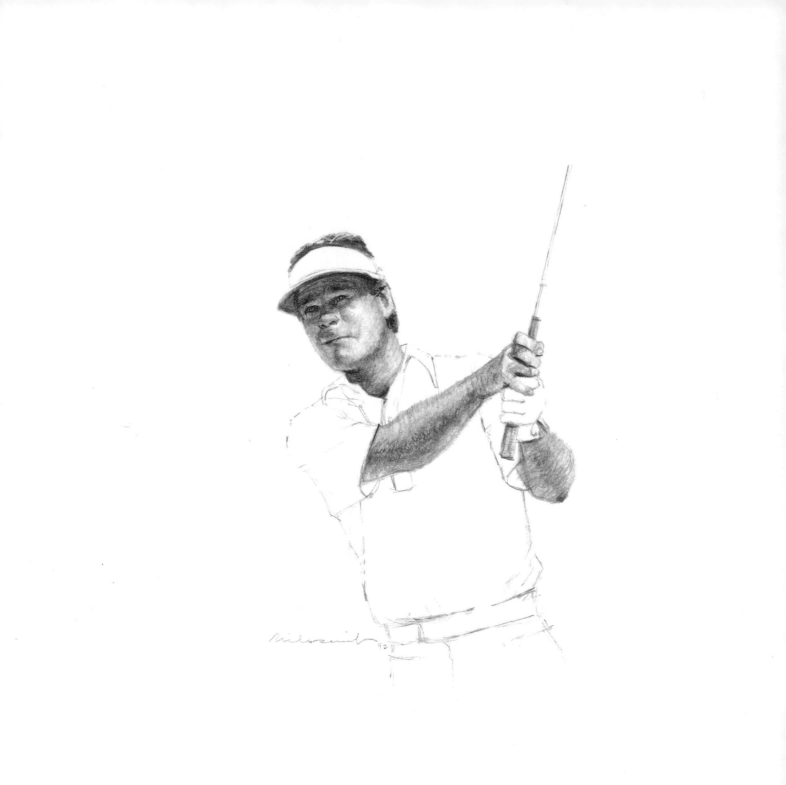

I've ever seen"—that his extraordinary talent in other phases of the game is overlooked.

"I tend to agree with that," Crenshaw says. "I can do a lot of things." In fact, Crenshaw may be as adept around the green as on it. Two examples:

1984 Masters, fifteenth hole, final round: Crenshaw's eighty-six-yard third shot on this par five must carry a lake and stop on the elevated, brick-hard green before rolling into another lake over the green. His lie is slightly downhill. Crenshaw leads by one and desparately needs a birdie. Imagine trying to hit and hold a highway overpass from the road below . . . while a huge gallery holds it's breath and the television cameras zoom in on your ball, your hands, your face.

"It was a scary shot. My lie was a little thin and the pin was on the left side of the green, where it's most shallow," Crenshaw recalls. Somehow, he hit a high, soft shot that finished twelve feet from the hole. He made the putt. He won the tournament.

Nineteen-Eighty-Six Buick Open, thirteenth hole, final round: Again, Crenshaw is fighting to hold a one-shot lead, but he hits a wild four-iron second shot on this par five that stops against the trunk of a tree. He has no shot—or does he?

"My only shot was with a nine iron, upside down—left-handed," says Crenshaw. He hits the damnedest pressure shot anyone has ever seen: from forty yards and between trees, Crenshaw's left-handed hack stops four feet from the hole. He makes the birdie putt, of course, and wins the tournament.

Crenshaw's heroics with his clubs, his polite, easy-going persona, and the perception that he gives back to the game—his hobby is reading and writing about golf—make him one of the sport's most appealing figures. "I realize how lucky I am in so many ways," he says. "I have a wonderful wife [Julie] and children [Katherine and Clare]. I'm so thankful that growing up, I had my father and Harvey Penick as teachers, and Bobby Jones as a hero. How could I go wrong?"

Ben Crenshaw has sixteen career PGA Tour victories as of this writing, including the 1984 Masters. He won the NCAA individual championship three times. He also played on the 1981, 1983, and 1987 Ryder Cup teams.

Jacky Douglas Cupit

Born: Greggton
Residence: Dallas

I cherish being inducted into the Texas Golf Hall of Fame. That was the highlight of my career.

The Cupit boys played golf. Buster was the best of the bunch, better than brothers Homer, Vernon, Bobby, David, Jerry, Freddy, and Jacky (two sisters, Bonnie and Mary, didn't play golf). The other boys mimicked Buster's peculiar swing, which featured a raised right elbow on the takeaway, as if full exposure of the right armpit was the object of the backswing. The resultant loopy, outside-to-inside stroke wasn't pretty. But it worked.

Buster's position as the pre-eminent Cupit golfer ended on a warm football Friday night in Longview in October 1955. The Pine Tree High School Pirates were playing their arch rivals, the Kilgore Bulldogs; little (five-foot-eight, 150-pound) Jacky, the youngest Cupit boy, played defensive back for Pine Tree. In the first half, Jacky "got his bell rung," which is the euphemism football announcers and coaches use for "concussion." He awoke that night in a strange bed.

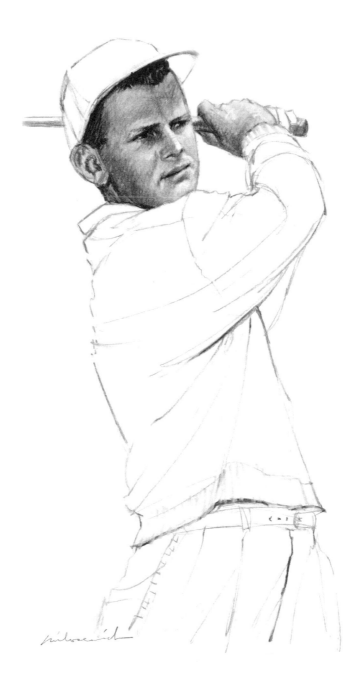

"All I remembered was tacklin' a big fullback. I got him down but he ran over me," says Cupit. "It was the first time I was ever in a hospital. Heck, I was even *born* at home. That was when I decided to pursue golf."

Cupit followed fellow Greggton resident Richard Parvino to the University of Houston and became, according to UH golf coach Dave Williams, "maybe the greatest player we ever had. You know he didn't make a double bogey his entire junior year? And I never did see him miss a fairway." Cupit played on two Houston teams—the 1958 and 1959 squads—that were undefeated.

He turned pro in 1960 and made a very good living on the tour. But for a hooked three wood on the second to last hole of the 1963 U.S. Open at The Country Club in Brookline, Massachusetts, Cupit's very good career would have been immeasurably better. Cupit was leading the Open by two with two holes to play; then, he hit that little hook.

"My ball stopped on the upslope of a fairway bunker. I couldn't go for the green—I had to play it back into the fairway," Cupit recalls, sadly. He got his next shot onto the green and only needed to two-putt to take a one-stroke lead into the final hole of golf's most important tournament. He three-putted.

"On eighteen, I hit a six-iron second shot fifteen feet to the right of the hole. I hit an excellent putt—I could stand there from now on and not hit one better—but it didn't go in." Cupit sighs. "The next day in the play-off (with Arnold Palmer and Julius Boros) I made it from the same distance on seventeen to get within two—then Boros [the eventual winner] made his putt, too."

Jacky Cupit played on three NCAA championship teams. He won four PGA tour events and was runner-up in the 1963 U.S. Open.

Bettye Mims Danoff

Born: Oak Cliff
Residence: DeSoto

I'm proud of playing The Babe—and beating her. And to have done all that traveling and met all those nice people—I wouldn't take for that expe rience. And I was proud of the fact that I could go play two or three tournaments and play pretty close to the girls who were playing all the time. And my three grown daughters and five grand children and two great-grandchildren.

"I can talk," Bettye Mims Danoff says needlessly. Her chatty manner once earned her the reputation of being a slow player. "That [reputation] used to aggra-vate me a lot," she says. "People thought I was slow because I would walk down the fairway and see someone in the gallery I maybe hadn't seen for a while, well, I'm not gonna walk on by. So many of the girls were so serious. Talking relaxes me. I guess I learned it from The Babe."

Babe Didrikson Zaharias had won an unprece-dented seventeen straight amateur tournaments and the attention of the golf world in 1947. She seemed

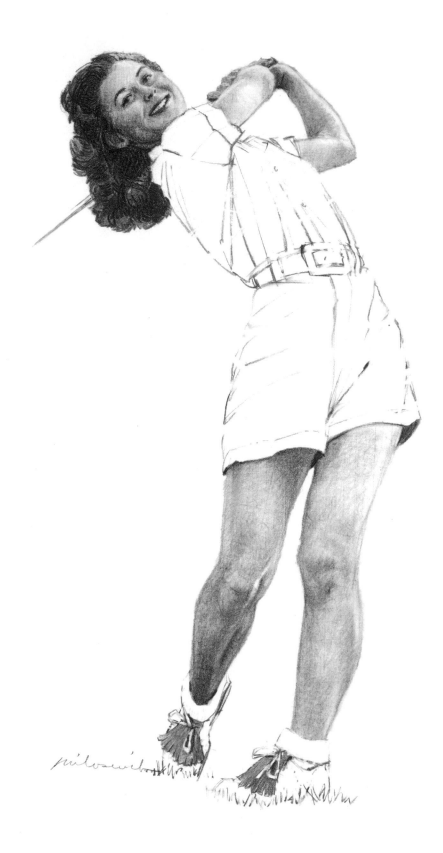

poised to make it eighteen in a row that fall in the Texas Women's Open at Rivercrest Country Club in Fort Worth. Her opponent in the quarterfinals was a petite, pretty girl named Bettye Mims White (Miss Mims had had a brief, "bad marriage" to a Mr. White, before marrying Dr. Clyde Walter "Danny" Danoff in 1949). The biblical equivalent of the match would be David versus Goliath; Nancy Lopez against your junior club champion is a modern comparison.

"Before we played, my daddy said, 'You know you can't beat her; just don't let her beat you eight and seven,'" recalls Danoff delightedly. "We got to the final hole—a long par five—and I was one up. I'd stayed one or two up all day. I hit my best drive of the day and a two wood and I still had a full eight iron to the green. The Babe hit a drive and a three wood and was just off the edge of the green in two.

"I hit my eight iron about seven feet from the hole. Then The Babe hit a bad chip—to about ten feet—but then she holed it. I had this big, curling putt; I knew I had to make it because I knew I didn't want to go extra holes." She made it; the Zaharias streak was over.

Bettye Mims grew up on the Sunset Driving Range in Dallas, an enterprise her parents started in 1929. "When we'd run low on balls, Daddy would stop the players on the tee and I'd run out there and pick 'em up," Danoff says. "We didn't have a pick-up machine, just me [and two older brothers] with a basket and a cup on a stick."

Her father, D. D. Mims, entered little Bettye in her first junior event when she was twelve; she was the only girl in the tournament. But by then she was already used to hitting golf balls for an audience. "People at the range would always say 'Hit some balls for us.' I always hit a driver." After an excellent amateur career, she turned pro in 1949. She found herself paired with her heroine, Zaharias, in her first professional tournament. "I had the honor on the first tee, and kept it for seven holes," the trim, animated Danoff recalls. "Babe said, 'How come you play so well against me and goof up against everyone else?' Boy, that needle went in deep!"

Bettye Mims Danoff won the Texas Women's Amateur in 1947 and was medalist in the Women's U.S. Amateur in 1948. She is one of thirteen charter/founding members of the LPGA.

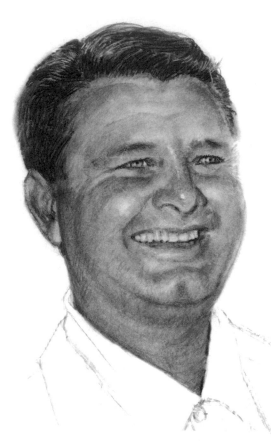

James Newton Demaret

Born: Houston, 1910
Died: Houston, 1987

Receiving this award [from the PGA as one of the ten outstanding professionals of the last fifty years] provided me with one of the most wholly satisfactory and proud moments of my life.

[Winning the Masters three times] represents the proudest and most satisfying competitive victories in my career. From the *Jimmy Demaret Golf To Music Lessons*, 1959

Purple shoes. Three-tone cardigan sweaters. A smile, a drink, a joke, and a song. That was Jimmy Demaret.

"I remember when I was a little girl going to my first golf tournament," says golf writer Frances Trimble of Houston. "My mother told me to follow Demaret's group so I wouldn't get lost. 'He's the man wearing the lime green pants. You won't lose him in the crowd.'"

And Demaret was usually in a crowd. His nickname was Sunny. He was gregarious, magnetic, and hated to be alone. Dave Marr calls Demaret "the best-

loved man in Texas golf history." Another old pal, Charlie Crenshaw, Sr., (father of Ben), recalls meeting Demaret at Hermann Park golf course in Houston.

"I'm proud of the fact that I knew Jimmy, that we became friends," says Crenshaw. "But he was friends with damn near everybody, from the top of society to the bottom.

"Jimmy would usually go from the golf course to the drinkin' hole, usually until two a.m. But he handled it real well. He had remarkable vitality."

Demaret's vitality often would manifest at "the drinkin' hole" if a band was playing. "Then, as

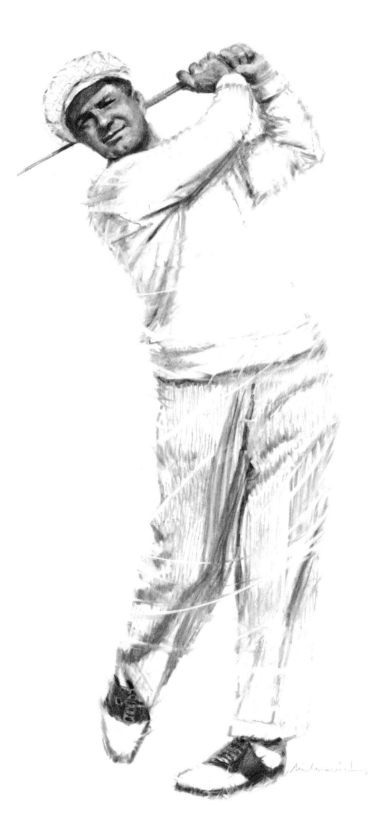

now," said Demaret in 1976 "I'd jump up on the stand and croon a ballad or two with the orchestra if given the slightest encouragement."

Added Demaret's life-long friend and business partner Jack Burke, Jr., "Yeah, and he'd always make certain one of his friends furnished the encouragement."

On one such evening in 1935 at the Hollywood Dinner Club in Galveston, Demaret allowed the Ben Bernie Orchestra to accompany him on a few songs. "Jimmy," said the band leader, impressed, "how would you like to sing for us full time?" Demaret was tempted. He wasn't making much money as the professional at Galveston Country Club; but he declined.

Charlie Crenshaw remembers another occasion when the night, the wine, and the mood moved Demaret musically. "It was the Odessa Pro-Am in 1953 or 1954. There was a get-together at someone's house. Must have been seventy-five people there. Pearl, Ben's mother [now deceased] was an exceptional pianist. She played and Jimmy sang. 'Play "Stardust!"' someone would call out or 'Play "Blue Heaven!"' Jimmy must have sung forty solos."

Lee Trevino remembers Demaret the quipster. Trevino once was paired with Demaret in a charity tournament in Los Angeles. With television cameras running, the announcer asked Trevino how it felt to be playing with a legend like Jimmy Demaret. "I thought I should try to be funny. 'It just feels fantastic,' I said, 'but he's old enough to be my father.'

"'And she was a good old gal!' Jimmy said, never changing expression."

Of course, the first thing that gets lost when a Jimmy Demaret story is repeated is that he was a great player. "I'm sure his personality kept people from recognizing just how good he was," says Burke. "He didn't have to practice as much as Hogan; he was a much more natural player than Ben. So he had more time for people, for fun. His strength as a player was that he had no weaknesses. He and Sam Snead played with an aura; they could do no wrong."

In the unofficial PGA Tour all-time rankings, Demaret is number twelve, ahead of Lee Trevino, Tom Watson, Walter Hagen, and Gary Player.

Demaret's surface brilliance—his clothes, his singing, his smile—obscured other aspects of the man. For instance, Demaret was *in loco parentis* for two of his younger friends, Burke and singer/golfer Don Cherry, both of whom lost their fathers. "I was closer to Jimmy than to my own father," whispers Cherry, overcome. "He was deep, deep as anyone I ever knew."

There is additional evidence that Demaret was more than just a peacock who could play a little golf: he was the favorite playing partner and one of the closest friends of Ben Hogan, golf's perfectionist. With Burke, he founded Champions Golf Club in Houston, one of the finest facilities in the world. He designed Austin's Onion Creek, another excellent golf course, home of the first major seniors tournament, The Legends of Golf. The Legends was Demaret's idea, too; he thus was one of the founders of today's very successful Senior PGA Tour.

In 1959, Demaret did some deep thinking about the game that had brought him out of poverty and into the limelight. The result was the *Jimmy Demaret Golf To Music Lessons*, a collection of pamphlets and five 45 rpm records. Charlie Crenshaw helped him put it together. It didn't sell. Demaret's most profound insight on learning the golf swing was that "it's rhythm that counts. If it were possible at all times to use it in teaching, music would become as fundamental a part of golf lessons as a professional's voice itself."

On the records are instrumental interpretations of the various golf shots: flutes and guitars for putting, a three-part clarinet "blip-blip-blip" for chipping, the entire symphony for the driver. It's bizarre. The best part of the package is Demaret's bouncy rendition of "The Swing's the Thing" on the last record. You imagine him standing in purple shoes as he sings: "In the office you're a peasant / on the golf course you're a king / with a club in hand / say, you're livin', man / the swing's the thing."

Jimmy Demaret had thirty-one PGA tour wins, including the Masters three times. He was an undefeated player on four Ryder Cup teams. He won the Vardon Trophy in 1947 and is a member of the PGA Hall of Fame.

Keith Carlton Fergus

Born: Killeen
Residence: Sugarland

*I'm proud of my tour wins, of course, and of help-
ing design Old Orchard Golf Club in Sugarland.*

Keith Fergus does not want to be the answer to a
trivia question, but he is. "Who coached the Univer-
sity of Houston golf team after Dave Williams?"

Williams won sixteen National Collegiate Athletic
Association titles and produced umpteen touring
golf professionals, including Fergus, his successor. In
Fergus's first two years in charge, the Cougars won
only the Southwest Conference's "Most Improved
Team" award—twice.

"Coach Williams had a record that will never be
touched," says Fergus. Williams's act has been hard
to follow, not only because of the tournaments and
titles his teams won, but because near the end of the
old coach's tenure, the best players stopped coming
to Houston. Fergus did not inherit a lot of talent.
"We've had to use four freshmen in some tourna-
ments," he admits.

42

So why did Fergus quit the tour in the prime of his competitive life to take such a can't-win job? First of all, he likes the challenge and is undaunted by his old coach's big shoes. "No, I don't coach the way Dave Williams did. I do my own deal," he says. Another thing which lured Fergus back to the campus: after a dozen years on the tour, he was sick of hotel rooms. "I got to the point where I wasn't enjoying it anymore. I missed my family [wife Cyndy and children Steven and Laura] too much. I miss the competition, but I couldn't go back to the tour now."

Fergus got hooked on golf after caddying for his father, who was several times the Killeen city champion. "I remember one day when I was about ten, I'd played forty-five holes when my dad came to pick me up. I wanted to play another nine and got mad when he wouldn't let me," he recalls with a laugh. And as much as he liked to play, he enjoyed practice even more. "I could stay on the practice range forever. You've got to prepare to play this game. If you go into a tournament unprepared, without enough practice, you'll choke like a dog."

The well-prepared Fergus won the Texas State Junior in 1971. A week later, the phone rang: "Hi, Keith, this is Coach Williams at the University of Houston."

There was no decision to make. "When I grew up, if you wanted to be with the best, you went to Houston," Fergus says. "It was tough, though, because, like my dad, I'd been an Aggie all my life. My not going to A&M hurt a lot of my relatives."

He shot sixty-five and sixty-nine in his first college tournament and finished second to Ben Crenshaw. Hmmm, maybe I can make a living at this, thought Fergus. He could. After graduating from UH, Fergus won the Texas State Open in 1976, his first full year on the tour. He was a solid—at times superlative—touring pro for the next decade.

Now Fergus is content to be perhaps the best golfer ever to coach a college team (Henry Ransom supporters could debate the point). He sleeps in his own bed, is part owner of a new golf course, and experiences pleasant feelings of deja vu while watching his team play or practice. "I see myself in them," he says.

"I try to relate my own experiences to the team. You know, the mental part of golf is so dadgum important. The great players were all great thinkers."

Keith Fergus won four times on the PGA tour, including the 1981 Memorial. He also won the Southwest Conference tournament in 1974 and 1976.

Richard Morgan Forester

Born: Birmingham, MI
Residence: Houston

Being a Yankee and getting elected to the Texas Golf Hall of Fame.

"Scores of the last twosome. Peter Jacobsen, 70! Tom Kite, 73!" A distinguished looking gentleman wearing a blazer and golf clothes calls out the scores in a voice that is loud, unaccented, and penetrating; he doesn't use or need a microphone or amplifier. "Approaching the 18th green . . . Greg Norman and Mark Calcavecchia!" The crowd of several thousand applauds. The announcer, Dick Forester, a youth of seventy-five, sits down. He loves doing this.

"I was the eighteenth green caller at the PGA Championship for fifteen years and for thirty years, off and on, down here," says Forester. After almost fifty years in the area, Forester, a native of Michigan, still calls Houston "down here." "The first one I did was the Houston Open in '46 at River Oaks. Hogan won. Or was it Nelson?"

Forester was then the pro at River Oaks; Jimmy Demaret had recruited him to take over for the

44

recently deceased Jack Burke, Sr., in 1944. In 1947, Forester began his twenty-two-year tenure at Houston Country Club, which he left to help build, co-own, and operate Bear Creek, which became the best public golf facility in Houston. In forty-something years in Houston golf, Dick Forester has made his presence felt—and his voice heard.

"I got the Ryder Cup here [at Champions Golf Club, in 1967]," says Forester. His tone is matter-of-fact, not boastful. "I was on the PGA board. We were discussing where to hold the event, so I told them 'Let me talk to Jimmy [Demaret, with Jack Burke Jr., the co-owner of Champions].' Jimmy said 'Yeah' and I said 'Well, I got all the votes if you want it.'

"It was the most stirring thing you ever saw: before the matches, we had the University of Houston band out on the first fairway to play the national anthems. But it was foggy that morning; you could hear them, but you couldn't see them."

Forester had used his persuasiveness and political skill to bring another high profile event to Houston in 1964: Ben Hogan vs. Sam Snead, in Hogan's first (and last) television match, at Houston Country Club. It was quite a coup for Houston—but the members at ultra-exclusive HCC didn't really need or want the attendant publicity. They especially did not want the crowds. The *New York Times* sent Red Smith to cover the event. "The Houston Country Club," he wrote, "has gold dust instead of sand in the traps and the greens are irrigated with oil. It is the home base for those hackneyed caricatures, the Texas zillionaire and his lady hung with ice cubes." Forester orchestrated a compromise: HCC would host the two-day affair—and actors would be hired to help portray a gallery for the TV cameras.

In addition to getting Houston big golf exhibitions, Forester gave Houstonians a place to play golf. "We ran and maintained Bear Creek like a country club," he says. With the opening of the fifty-four-hole public facility in the early 1970s, amateur golf in the Houston area "changed from a country club sport to a game for the masses," wrote Houston golf writer Frances Trimble, "and Forester's promotional instincts provided the necessary push."

In less obvious ways, too, Forester elevated his profession and the game. Five of his former assis-tants are head professionals today; his sons Rick and Jack are also in the golf business. He suggested the idea for the first golf cart to Dick Jackson, one of his HCC members who suffered from arthritis; Jackson then built and patented a usable cart. Forester volunteers to run junior events, and serves as rules chairman for college and PGA chapter and section tournaments. And he helped start the Houston Women's City Championship, the Texas State Open, and the Houston Golf Association.

"I'm just trying to make golf better," Forester says. "Why not? Someone did it for me when I was young. I want the game to be better for these kids down the road."

Dick Forester has served as president and secretary of the Texas and South Texas Sections of the Professional Golfers' Association of America and on the Executive Committee of the National PGA. Forester, a member of the Texas Golf Hall of Fame, says he smokes six cigars a day, down from ten or twelve; he smokes only "Travis Club Senators, hand-wrapped in San Antonio."

Aniela Gorczyca Goldthwaite

Born: Fort Worth
Residence: Fort Worth

I'm proudest of my children. And what I've gotten out of golf.

Aniela Goldthwaite has never seen this before. She gazes at the 1933 issue of *Richardson's Annual Golf Review* in the bright light from her office desk lamp. Transfixed, she turns the yellowing pages of the old magazine to page forty-four. And there she is—a tall, slim girl in a long skirt, saddle shoes, and a full follow through. Under the photograph it says "She put Fort Worth in golf's front ranks." The accompanying story begins: "Aniela Gorczyca, 21-year-old Fort Worth star, won the 1933 Southern Women's Championship at Radium Springs, Albany, Ga., by defeating Mrs. Ben Fitzhugh of Vicksburg, Miss., the defending champion, 1-up in the 36-hole final . . . "

Memories come flooding back. Nineteen thirty-three, Goldthwaite recalls, was a big year. "I won the city, state, and Southern tournaments," she says, "I also met Frank Goldthwaite in '33, when I made my debut. We were married nine months later." Frank

48

Goldthwaite owned a successful golf course mower and irrigation equipment distributorship; after his death in 1960, Aniela took over. When the children (daughters Aniela and Frances, and son Frank, Jr.,) reached their majority, they also joined the family business, which thrives today.

While Aniela Goldthwaite gained considerable notice as a woman Chief Executive Officer, her skill with a golf club won her more lasting fame. From 1930 until World War II, she seemed to win everything she played in: the Fort Worth City Championship ten times, the Texas Women's Open four times, and the Women's Texas Golf Association Championship three times. Ben Hogan watched Goldthwaithe defeat Helen Hicks in the finals of 1938 Texas Women's Open. In his guest commentary on the match for the *Fort Worth Press*, he wrote "I saw the greatest performance by a woman golfer in the history of the game at Colonial yesterday."

As a golf administrator, too, Goldthwaite made a splash. She was on the United States Golf Association's Women's Committee for eight years and was chairman for two years—"the first Texas woman to be a USGA chairman. I'm proud of that."

Goldthwaite forgets to ask for a copy of the 1933 magazine article from her visitor as he leaves. But she is busy, after all; she has a business to run this morning and a golf game this afternoon.

Aniela Gorczyca Goldthwaite played on the Curtis Cup teams of 1934 and 1936 and was the team's nonplaying captain in 1952. She was a semifinalist in the U.S. Women's Amateur in 1941 and was runner-up in the 1966 Women's Senior Amateur. She works at Goldthwaite's of Texas, Inc., "every day." By the desk in her office are three golf clubs.

Ralph Guldahl

Born: Dallas, 1911
Died: Sherman Oaks, CA 1987

I think the thing he was proudest of was when he won his second U.S. Open at Cherry Hills. It proved he was not a fluke. Laverne Guldahl

The best player in the world in the late 1930s was a big Norwegian from Dallas named Ralph. Although Sam Snead won more often in that period, the tournaments Snead won had names like the Anthracite Open and the West Virginia Closed Pro. Ralph Guldahl, on the other hand, was, for a few years, the man to beat in the most prestigious events in golf. He took the Western Open three years in a row (1936-38) at a time when the Western was considered a "major." And he won back-to-back U.S. Opens (1937-38) and the Masters in 1939.

"Ralph was a very wonderful player in the late thirties and early forties," recalls Byron Nelson. "He had a very short career but a very good one. He was pretty much a loner. On the golf course, he was very methodical. The original bad slow player."

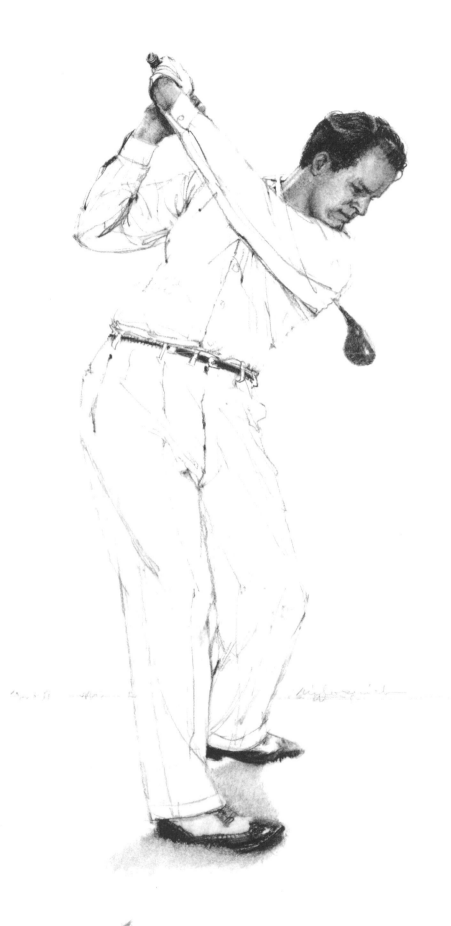

51

It was, by all reports, something of a trial to watch Guldahl play golf. As Charles Price wrote of him in *The World of Golf* (published by Random House, 1962), "Guldahl would often stand over the ball so long that people in the gallery would start glancing at their watches . . . [he] stood very close to the ball and hunched his shoulders in such a way that he appeared to be standing almost on top of it—even with a driver . . . After taking his stance, Guldahl would squirm and wiggle like a man backing into a phone booth with a load of packages in his arms, and then finally . . . draw the club back with explosive speed and hit the shot with a violent uppercut, the force from which left him balanced precariously on his heels."

Other golfers have been successful with unorthodox technique—Miller Barber comes to mind—but another aspect of Guldahl's makeup was unique. So compelling was his love for his wife—the former Laverne Fields of San Angelo—that he couldn't bear to be without her, even for a week. So when Laverne had had enough of life on the tour, Ralph just quit. He was thirty-four.

"Our son, Ralph, Jr., was getting to be a teenager, and I had been away off and on since he was two and a half," explains Laverne Guldahl, a woman of four score years whose voice, incredibly, is that of a girl of sixteen. "And then, one year—1945 or '46—we almost got it. Our trailer skidded off a snowy road in New Mexico."

So the next spring, Ralph Guldahl prepared to go out on the tour—alone. "I heard him cry as he packed his bag in the den, and he cried all the way to the train station," Laverne recalls.

After a tearful goodbye at the depot, Laverne and Ralph, Jr., drove back to the Guldahls home in San Diego. The phone rang. It was Ralph. "Honey, I'm calling from Los Angeles. I don't know if we should be apart like this. How are you holding up?"

Laverne was holding up fine, she remembers with a laugh; "I was about to go out shopping with a friend. But Ralph took the next train back. He even had the same porter, who must have thought Ralph was having marital problems."

Laverne Fields, tiny, lively, and attractive, resembled a Gabor sister. Ralph Guldahl was large (6-foot-2) and taciturn. They met in 1931; opposites attracted. "A friend of mine and I wanted to take golf lessons together, so she called around town [Dallas] and booked lessons with the fellow who had the most personality on the phone," says Laverne.

After the first session, the friend said, "You may not have noticed it, but that pro, Ralph, never took his eyes off you."

Laverne decided to see for herself. At one point during the next lesson, she took the club to the top of her backswing, "Then I raised my head up. He was looking right at me."

The punchline was that Guldahl wasn't the Mr. Personality who booked the girls' lessons on the phone. "Ralph thought a lot but didn't say much. I think that's typical of Scandinavians," says Laverne. "Both his parents were from Oslo, you know."

After his abbreviated playing career, Guldahl had club professional jobs in San Diego, St. Louis, and Chicago. He ended his career at Braemar Country Club in Tarzana, California, near Los Angeles. "He was the finest gentleman I ever met in my life," says the longtime receptionist at Braemar, Mary Renfrew. "I didn't know anyone who didn't like him. A real southern gentleman." In honor of their pro of twenty-six years, the members renamed their restaurant The Guldahl Grille and filled it with pictures of Big Ralph.

"A week before he died [at home, of a heart attack], Ralph and I were listening to a hymn on the radio," says Laverne. "The last words of the song were 'I will love thee forever and ever.' I looked over and Ralph was crying. 'What's wrong?' I asked. 'Those words,' he said. 'That's the way I feel about you. I will love thee forever and ever.'"

Ralph Guldahl won sixteen times on the PGA tour, including the 1937 and 1938 U.S. Open and the Masters in 1939. He made the Ryder Cup team in 1937. He is a member of the World Golf, PGA, Texas Sports, and Texas Golf Halls of Fame.

Sandra Jane Haynie

Born: Fort Worth
Residence: Dallas

My record can speak for itself.

Sandra Haynie revolves through the air in slow motion, her feet describing a 360-degree arc, her head tucked forward. Her mind is in fast motion, recalling all the pleasure and pain of her young life. Haynie sees, in turn, the gray car that has just hit her, the blue South African sky, and the mottled black pavement of the Johannesburg street. She knows she is about to die.

But Haynie doesn't die. She lands on her back on the center stripe of the road as cars traveling in both directions swerve to miss her. Tires squeal, car horns blare, and Haynie wakes up in the hospital.

"I just looked the wrong way when I stepped off the curb. They drive on the left over there, like in England," Haynie recalls.

In the hospital, an inexperienced physician urges Haynie to get up off the exam table and walk. The doctor has misread the x-rays; she has two fractured vertabrae that he can't see but Haynie can feel. He

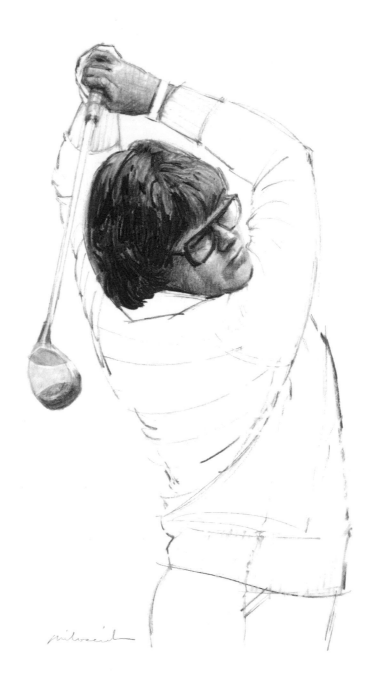

54

presses; walk, I'm sure you can walk, he says. "I'll walk," Haynie finally says, her temper up. "I'll walk right out of here."

Sandra Haynie was an only child. A natural athlete, she excelled in team sports. Then at age eleven, she picked up a golf club and never let it go. "What appealed to me about the game was that it was something I could do by myself. If a mistake was to be made, I wanted it to be my mistake. In team sports, you share the blame—and the credit."

Softball, field hockey . . . all other games were abandoned as Haynie pursued her new love. Jim and Mary Jane Haynie, sensing that this was a perfect game for their independent young daughter, would drop little Sandy off at the golf course in the morning and pick her up there at night ("I grew up on Austin Muni," says Haynie). She began to commute to River Crest Country Club in Fort Worth for lessons with A. G. Mitchell. That summer Mitchell, a dour Scotsman and a teaching professional of some renown, got Haynie an invitation to play in the Texas Women's Open. He also arranged for his prodigy to play a nine-hole practice round with another of his students, Babe Didrikson Zaharias.

"I know what I'm gonna do the rest of my life," Haynie announced to her parents afterward. "I'm playing the tour." She was twelve.

She kept her promise. She joined the LPGA tour in 1961, at age seventeen. "My parents said, 'You're young enough. If it doesn't work out, you can do something else.' Well, it never crossed my mind that it wouldn't work out."

It worked out. Instead of attending her senior prom in June of '62, Haynie, eighteen, won her first two tournaments, back to back. In July, she was in contention again, at the Kelly Girls Open in Maryland. But she three-putted the final green to allow an unknown, Kathy Whitworth, to win her first event.

"I was livid. Later, I was walking through the parking lot with two pairs of shoes in my hands. I thought no one else was around, so I just threw all four shoes and they came clattering down. But Patty Berg saw me and gave me a very firm lecture. 'We don't do that,' she said. I really appreciated that Patty cared enough to straighten me out."

The intense but under control Haynie won at least one and usually two tournaments a year for the next thirteen years. In 1976, she began to wake up thinking about the crash landing that had ended her exhibition tour in South Africa four years before. Her damaged spine had become arthritic; it hurt to get out of bed, much less swing a golf club. There was psychic pain, too; after eighteen years of competition, Haynie was burned out. She quit.

"Someone asked me once what I missed most about the tour," says Haynie. "'Throwing up every morning,' I said."

Sandra Haynie won forty-two LPGA events, four of them major championships, and had three wins during a comeback in the early 1980s. Advancing osteoarthritis in her back and knees now prevents her from playing golf, but does not keep her from a very active role with the Arthritis Foundation. She was inducted into the LPGA Hall of Fame in 1977.

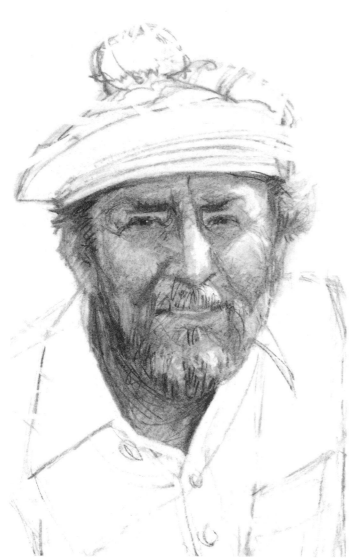

Johnny Ross Henry

Born: Corsicana
Residence: Ennis

I'm proud to have been the first college graduate in this area to be a greenkeeper; now most golf-course superintendents have gone to college . . . and I'm proud that I've preserved two hundred years of golf history through my collection of clubs and balls.

Johnny Henry gestures to a spot above his fireplace. All four walls of this high-ceilinged room are lined with wood-shafted golf clubs.

"This one may be my oldest club," he says. "It was made in Scotland in about 1790, probably by a bow and spear maker." Slowly, carefully, Henry removes it from the wall with a homemade gizmo that looks like a giant fork. The head and shaft of the ancient long-nosed club are made from beech, a pale yellow wood. "We don't know who built it, because the bow makers didn't sign their work."

Then Henry hands you one of the first iron clubs. It is a *rut iron,* a crude, tiny-headed instrument that was used to hit from wheelbarrow or wagon tracks.

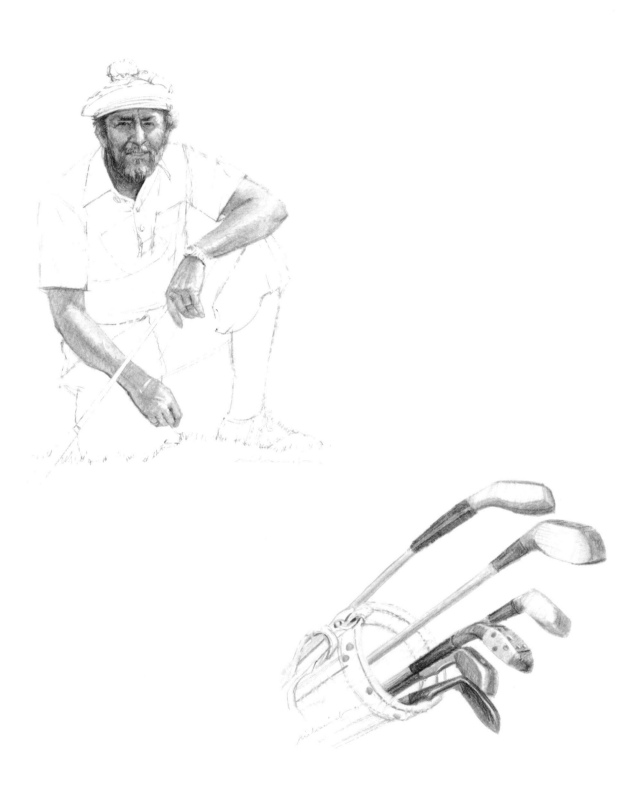

"Irons weren't used much in the early days," he explains. "Here's why." He hands you one of the first golf balls. It is a small, leather globe, stuffed with goose feathers. Iron clubs tended to split the very expensive "feathery" ball.

Two thoughts may occur to the visitor to Henry's home in Ennis at this point. First, that golfers through history have *walked* to their golf ball, then played it as they found it. Most players today do neither. And second, that in about two minutes, the visitor had handled two clubs and a ball worth about $35,000.

Henry muses about the highlights of a life spent in golf. When Henry was a boy, Patty Berg came to play an exhibition at his home course, Corsicana Country Club. Berg was in a traffic accident on her way out of town and spent the next week in the local hospital. Henry and his mother visited Berg every day. "She sure had a lot of freckles," recalls Henry. A few years later, at the 1941 U.S. Open at Colonial in Fort Worth, the thirteen-year-old Henry attached himself to Gene Sarazen. "I dogged his tracks—you [spectators] could walk in the fairway back then," he says. "I liked him because he was small, like me." Henry played a college golf match (he went to Texas A&M) against the sainted Morris Williams, Jr., of the University of Texas, and won—"the only match he lost in his college career," Henry says. During a ten-year stint as greenkeeper at Brookhollow Country Club in Dallas, Henry teed it up a number of times with Byron Nelson, and, now, twenty-five years later, he still tries to swing like Lord Byron. Henry also knew Hogan. "His handshake felt like no. 3 sandpaper," he recalls, a reference to Hogan's practice-roughened hands.

The diminutive Henry found his muse in 1975, during a golf trip to Scotland. There he met a gentleman named Ken Smith, who suggested, over a drink, that Henry might be interested in collecting antique clubs, and that he really should join the Golf Collectors Society. Now Henry has a rotating stock of one thousand of the best collectible clubs and is one of the Golf Collectors Society's leading lights; he often lectures on club restoration or early golf history at their meetings. Henry haunts the auctions in Scotland

and England during his annual return trips to the birthplace of golf.

"My first [collectible] club was this MacGregor Chieftain driver," Henry says. He takes it down from an honored place on his living room wall. "Beautiful club. Ivory back weight, ivory inlay here on top, and ivory dowels in the face. It sold for $25 in 1928 when run-of-the-mill clubs cost $2.50." You might get $850 for a set of Chieftains today.

Not that profit is Henry's motive for collecting. And it's not just that restoring and collecting "old golf stuff" makes him feel connected to the traditional game he loves so deeply. Henry is in it for the people. A self-described "international raconteur," Henry has more friends and knows more jokes than anyone since Will Rogers. "Have I told you this one?" he asks. "If I have, don't stop me, because this is a good story . . ."

Henry played on Texas A&M's 1949 Southwest Conference championship golf team. He also won the 1978 Hickory Hackers Open, a national tournament played with antique clubs. Henry has designed and built a golf course and served as a professional, greenkeeper, and salesman of golf-course maintenance equipment. His golf collection is one of the best in the world. He's worn knickers on the golf course since 1975.

William Ben Hogan

Born: Dublin
Residence: Fort Worth

The thing I'm proudest of is that I got better every day.

The PGA tour traveled by car in 1949. So after the Phoenix Open was concluded—Jimmy Demaret won, defeating the hottest player in the game, Ben Hogan, in a play-off—the players gassed up their Cadillacs and Buicks and headed east. The next tournament was in Texas, one thousand miles away.

Two of the tour's better players, Herman Keiser and Dutch Harrison, were riding together that week, part of the informal caravan. The drive was boring; the scenery, desolate. They rode silently, each alone with his thoughts, listening to the hum of the big car's tires on Texas Highway 80.

As they crested a hill between Van Horn and Kent, an hour or so east of El Paso, Keiser and Harrison were jolted by the scene in the valley below. On one side of the road was a badly dented bus and a jack-knifed eighteen-wheel truck. A bunch of people—bus passengers?—were milling around, looking cold

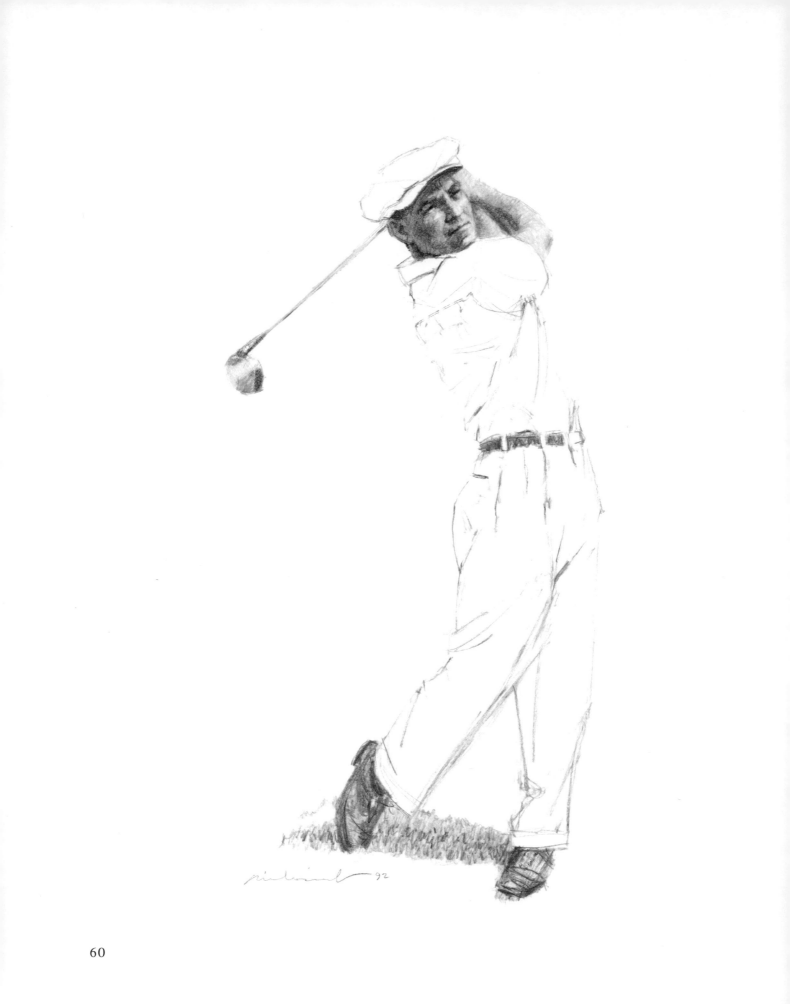

60

and confused on this chilly February morning. There were police and fire crews, an ambulance, tow trucks, the thin warble of a siren in the distance, the strobing of the overhead lights on the emergency vehicles . . . bad accident, Keiser thought. Must have been the fog over that creek.

Harrison continued to drive slowly through the aftermath of the crash and came to a third damaged vehicle. It was a black Cadillac, crushed like an aluminum can. "Looks like the bus hit it," Keiser said.

"My god," said Harrison. "That's Hogan's car!"

"We went to the hospital and Hogan was all strapped down," Keiser, the 1946 Masters champion, recalls. "It didn't look like he was going to make it." Hogan had a broken collar bone, rib, pelvis, and ankle; a severely bruised left leg; and massive internal injuries. The bus had rammed the car's engine into his left side and stomach.

Hogan gestured for Keiser to come closer. "Herman," he said softly, "would you check on my clubs?"

Outside the hospital room a few minutes later, Harrison said grimly, "The Little Man . . . we won't see him again."

Keiser disagreed. "Didn't you hear what he asked me in there? He'll be back."

June, 1950, Haverford, Pennsylvania, the final hole of the final round of the U.S. Open at Merion: in his first Open since his near-fatal collision, Ben Hogan is tied for the lead with one hole remaining. But he has bogied three of the previous six holes. For the large gallery watching him, the finish is almost painfully exciting, like watching a high wire act perform without a net. Will the trapeze artist fall? Hogan seems fatigued. Is the thirty-six-hole final round too much for him? It is, after all, less than a year and a half since The Accident. Hogan's legs are wrapped in Ace bandages. He is limping.

The eighteenth at Merion is a 458-yard par four, a brutal but lovely hole surrounded by huge elm, oak, and maple trees, by three large sand bunkers—and on this day—by people.

Hogan rips his drive through the corridor of trees and humanity into perfect position in the left center of the fairway. He trudges after his drive, his eyes straight ahead. Upon arriving at his ball, he draws so hard on a cigarette that it glows for an instant. Hogan tosses the burning weed and withdraws his one iron from his bag like a sword from its sheath. The caddy backs away.

Life Magazine photographer Hy Peskin has stealthily positioned himself about twenty yards behind Hogan. Peskin fiddles with light meter, camera lens, and view finder as Hogan addresses the ball. Peskin focuses; Hogan hits; the photographer snaps. The resultant photograph of Hogan in full follow through is the classic golf photograph. There is Hogan, "wiry, self-disciplined, austere," as British golf writer Henry Longhurst described him, perfectly balanced, in complete control; and there is the ball, a white blur just below the tree tops. The fairway and the green are perfectly framed by the huge gallery, who are themselves framed by the tall trees. The photo freezes a perfect moment, a dramatic few seconds on a summer day more than forty years ago.

The ball finished on the green. Hogan two-putted to tie George Fazio and Lloyd Mangrum, whom he defeated in a play-off the next day.

The Hawk was back.

Despite a career shortened by World War II, the injuries he suffered in his car accident, and personal preference, Ben Hogan won sixty-three PGA tour events, not including the 1953 British Open, which he won on his first and only attempt. For example, Hogan entered only six tournaments in 1953—and won five of them. He was Player of the Year four times, won the Vardon Trophy five times, won the PGA Championship twice, the Masters twice, the U.S. Open four times (five, if you count, as Hogan does, an "unofficial" Open held in 1945 called the Hale America) and the British Open once. He played on two and captained two other Ryder Cup teams. He is a member of the PGA and Texas Golf Halls of Fame.

Elizabeth May Jameson

Born: Norman, OK
Residence: Delray Beach, FL

I'm proudest of my golf swing. And the fact that I'm a pretty decent person.

The last group in the final round of the 1953 Jacksonville Open lagged behind the rest of the field. The threesome's tardiness was not the fault of Patty Berg, the eventual winner of the event, or of Babe Zaharias, who would finish second. The turtle in the group was Betty Jameson.

During the round, Jameson often had backed away from shots she was about to hit; her overdeveloped peripheral vision allowed her to see not only the ball, but improperly positioned playing partners and gallery members as well. Jameson, poised to hit a shot or a putt, would straighten, stand back from the ball, then, with shooing and traffic cop gestures, rearrange the adjacent humanity. Then, back to the shot—and another delay. "I took a lot of waggles, which bothered my opponents," Jameson admits.

On the spectator-ringed eighteenth green, Jameson seemed nearly ready to putt, when she noticed an ob-

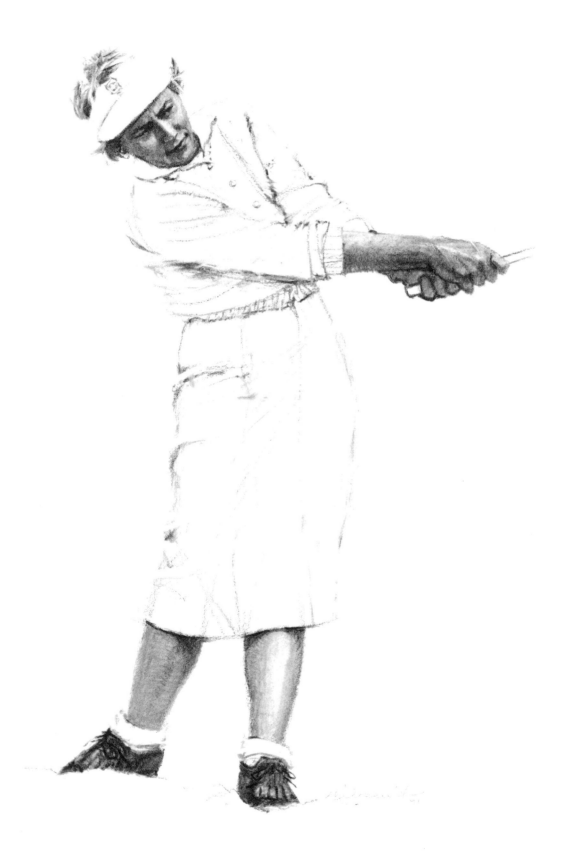

trusive onlooker directly in her line. She stood up. Suddenly, Zaharias shouted "I'll take care of this, Betty!" Zaharias waded into the gallery. "All you people go way over there! You folks move over to this side. Can't you see Betty's trying to putt?" The crowd roared with laughter.

"Babe made a big joke out of it," says Jameson, who laughed along with everyone else. "It was really amusing."

Jameson's deliberation on the golf course was caused by pefectionism, not by her waggles or her side vision. "In golf, you're hitting two things: the ball and your target," she explains. "I was always thinking about the sweet spot on the club face, the target, and taking dead aim."

That phrase—"take dead aim"—is the same thought that Ben Crenshaw and Tom Kite have before they hit a full shot. Harvey Penick taught all three. "I read recently that Harvey said he never really told us (Kite, Crenshaw, and Jameson) much," she says. "That's the greatest compliment I ever got."

Jameson's first love was tennis. "Grandma bought me a racket, but the public tennis courts around our house [in Dallas] had no nets. Others would bring their own nets. We didn't have one," she says. Then golf looked attractive; Jameson was impressed by the Fox Movie Tones (newsreels) she had seen of golf champions Helen Hicks and Glenna Collet Vare. "I used to turn around one of my fathers left-handed clubs and hit balls toe-first outside our apartment building. I had a great desire to play golf."

She finally played a round in the fall of 1930 with a set of sawed-off hickory shafted clubs. She was eleven. Two years later, she won the Texas Public Links title and two years after that, the Southern Amateur. She won back-to-back U.S. Women's Amateurs in 1939 and 1940. "My golf game was strictly an inheritance," says Jameson, explaining her success. "I copied the swing of Mr. Francis Sheider, the pro at Brookhollow."

Jameson turned pro after the war—and regrets it. "It was an untimely time. That whole decade [the forties] didn't have much to offer in women's golf. I really wanted to be a painter, an artist."

Who else is going to be in this book? Jameson wants to know. Don't you have Reynolds Smith,

O'Hara Watts, Neal Smith, Dennis Lavender, Spec Goldman? How about Pop Lewis or H. L. Edward? No, you say, but we do have Hogan, Nelson, Mangrum, Demaret, Zaharias, Trevino, and Whitworth. So you're in good company.

"Well," says Jameson, "so are *they*."

Betty Jameson, the 1947 U.S. Women's Open champion, was a founder and charter member of the LPGA. She won fourteen big amateur tournaments (including two U.S. Amateurs) and ten professional events. She originated the Vare Trophy, given for the low stroke average on the women's tour. Jameson is a member of the LPGA Hall of Fame.

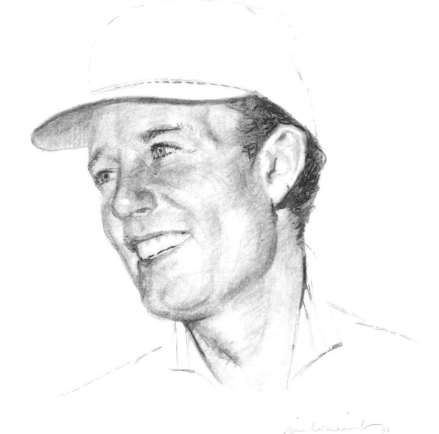

Donald Rae January

Born: Plainview
Residence: Dallas

What am I proudest of? Besides my family, you mean? The question's a little too broad. My PGA win, of course. And coming back to have my best year on tour at age forty-six, was very gratifying.

Don January is cool. His walk is unhurried, a sort of cowboy amble. His trademark upturned collar—his neck tends to sunburn—is very cool. He smiles sardonically at bad golf shots. He's unflappable, self-possessed. Cool.

January's composure on the golf course is fully expressed in his swing. Many players—including some very good ones—strike the ball with a constipated, over-controlled motion. They make golf look like work. But January has a swing you could dance to. It's free, relaxed, rhythmic, and huge. January's stroke describes a circle and a half; it looks like a ferris wheel.

"I've always had a big swing," January says. "It's these long arms [he wears a 35-inch sleeve]. I should be 6-foot-4 with my arms [He's 6-foot]." At the end

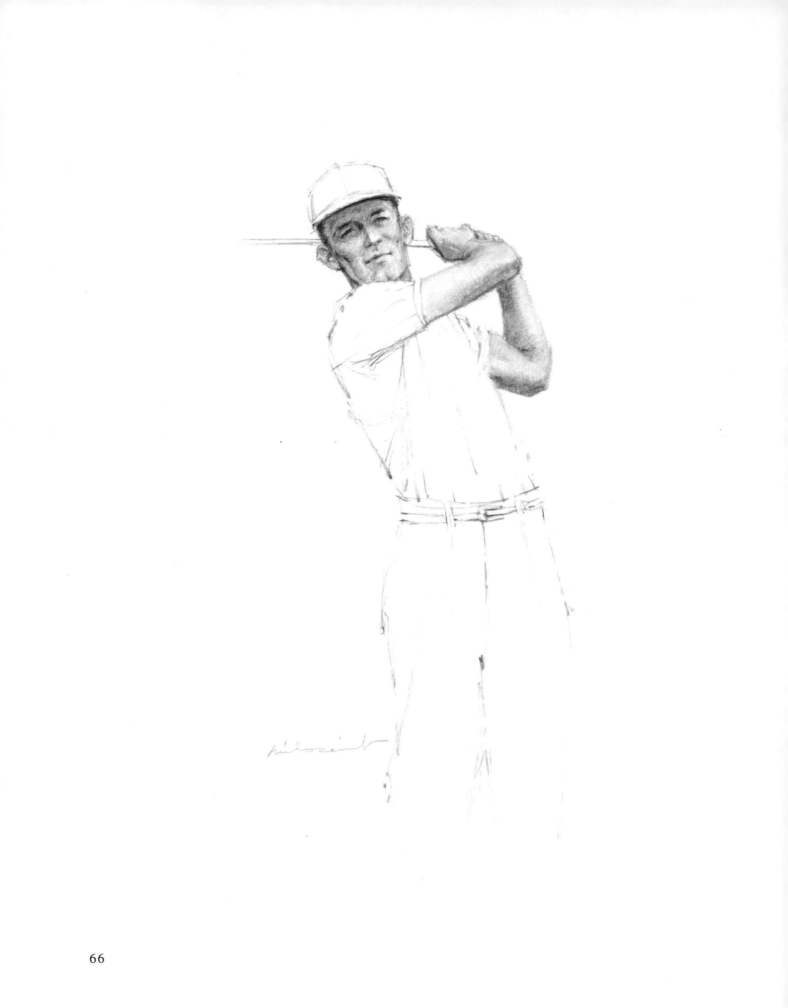

of his backswing, January can actually see the club-head out of the corner of his eye. *That's* a big swing.

It is also a lot of swing to keep track of. But it was even larger in 1956, when January, then a first year pro, played a round with Ben Hogan. "It was my fourteenth week on the tour. I didn't want to bother him—he was so *big*. But I told him after the round that I was new on the tour and asked what did he think of my swing. Hogan said 'Is there something wrong with your elbow?'"

Four years later, January deciphered the meaning of Hogan's cryptic remark. He had decided to make a major change in his game; his wildness off the tee "made my stomach hurt at night a lot. You ain't got a cut dog's chance in hell to win on the tour if you can't hit it straight." So January stopped "rocking off the ball" (swaying) on his backswing, moved the ball closer to his feet at address—and discovered that Hogan had been referring to the unorthodox position of his *right* elbow, not his left, as he had assumed. Hogan hadn't said which elbow he meant, and "I was too young or too scared to ask," January says.

The changes cut down his considerable length with a driver—"I had enough to give some away," he says—but now he could find his ball. His already good golf game got great. January almost won the 1961 PGA Championship at Olympia Fields Country Club near Chicago. "I was getting my acceptance speech ready," recalls January, when Jerry Barber started to make putts: "from twenty feet on sixteen, a forty-footer for par on seventeen, and from sixty feet—*in the dark*—on the final hole. That ball went across a ridge, down a valley, up over *another* ridge." January had lost a four-shot lead with three holes to play. Then he bogied the final hole of the play-off the next day to lose by one shot. Here was a true test of January's *sang-froid*. Yet despite the infuriating circumstances of his defeat, January was able to smile and shake Barber's hand. "I was taught to act that way by my daddy. It's just part of sportsmanship," January says. "You either learn it or you don't."

Six years later, in the 1967 PGA at Columbine Country Club, January was again tied for first at the end of regulation, this time with Don Massengale. But in this play-off, on a hot day in Denver, the cool man won.

Don January won ten times on the PGA tour, including the 1967 PGA. He was a member of three NCAA championship teams at North Texas State, won the Vardon Trophy in 1976, and played on two Ryder Cup teams. He ranked in the top four money winners on the senior tour from 1981 to 1986. As of this writing, January has won twenty-two senior tour events.

Dan Thomas Jenkins

Born: Fort Worth
Residence: Ponte Vedra Beach, FL

I suppose I'm proudest of the fact that I chose the profession I did. That I've known and played golf with people like Hogan, Arnold Palmer, and Jack Nicklaus. And that I've been to more major golf tournaments—twice as many—as any other writer.

Dan Jenkins is the only golf writer many people have ever read. As the man at the Masters (or the U.S. Open, British Open, Ryder Cup, what have you) for *Sports Illustrated* for twenty-three years, a generation of readers depended on him to tell them what the newspapers and the televison Brent Musbergers could not. What did Palmer say to his caddy after he birdied the first hole? Who was in the bar last night? Why did Trevino go to a five wood? Where was Nicklaus all week?

Ex-newspaperman Jenkins stubs out a Winston and takes a sip of decaf. "I love deadline pressure," he says through the mingled smoke of tobacco and coffee. "I'm a deadline junkie." His legendary golf

tournament reportage for *SI* was done often in one fell swoop, without notes, on Sunday evenings. No timorous pecking away during the week for Jenkins; he loved the challenge of getting it in—and getting it *right*—at the last minute.

While he is hardly the first good golf writer—names like Bernard Darwin, Henry Longhurst, Herbert Warren Wind, and Charles Price come to mind—Jenkins may be the most readable. And he originated a new kind of golf writing, which incorporated informality, insight, humor, and the sudden notion that golf, after all, is not brain surgery.

This distinctive writing style revealed itself to Jenkins in 1952, on a Sunday afternoon in Georgia. As he recalls in his second book, *The Dogged Victims of Inexorable Fate*, "I was covering the Masters tournament for the (now defunct) Fort Worth *Press* . . . A typewriter I was using in the Augusta press room did a quaint and curious thing. On a hasty deadline, it wrote, 'Sam Snead won the Masters yesterday on greens that were slicker than the top of his head.'"

Jenkins would become famous for one-liners like that. "Dan is one of the best humor writers I've ever read, and he has the best 'ear' I've ever been around," says Blackie Sherrod, Jenkins's editor at the *Press*. Sherrod, himself a wonderful writer—he is the lead sports columnist for the Dallas *Morning News*—hired Jenkins out of high school. "Someone brought me a column he'd written for the Pascal High *Pantherette* [it parodied the writing of the sports staff at the *Star-Telegram*, the *Press*' rival]," Sherrod recalls. "So I asked Dan to bring me a couple more, and we hired him to work part-time while he went to TCU. The pay wasn't good. None of us was drivin' limos.

"The *Press* was sort of strange. It didn't have much circulation or much money, so we [Sherrod, Jenkins, and two other eventually well-known writers, Bud Shrake and Gary Cartwright] decided to have fun. We did a lot of reading—Perelman, Thurber, Chandler, nonsports authors. It was a thing like we were writing for each other."

In addition to virtually requiring a time limit to write—he imposes deadlines on himself if an editor or publisher won't—Jenkins carries at least two other souvenirs from his fifteen years on a daily: his typewriter ("It's an Olympia—I won't use a word

processor") and his productiveness (he wrote thirty-five stories in 1963, his first year at *Sports Illustrated*, twice as many as any other writer). He also retains the ability to express himself forcefully, acquired when he was writing six newspaper columns a week. For example, regarding the renaming of golf tournaments by their corporate sponsors, Jenkins recently wrote, "His Lordship Deane Beman of the PGA Tour . . . couldn't wait to jump gingerly in the corporate cesspool and go breast stroking through the [corporation] logos." And he is tired of being confronted by militant antismokers seemingly every time he ignites a Winston. He tells one such "loon" in a recent column, "I'm under a doctor's orders. If I don't smoke, I may go crazy and kill you."

In consecutive assignments for *Golf Digest*, the country's best golf writer played eighteen holes with President Bush, then spent several days at Augusta National as the guest of the club's president, Hord Hardin. "I can't believe how powerful that man is," says Jenkins. He means Hardin.

Dan Jenkins is the author of eight books, including best sellers *Semi-Tough*, *Dead Solid Perfect*, and *Baja Oklahoma*. His current book, *You Gotta Play Hurt*, is about a year in the life of a sportswriter named Jim Tom Pinch. Jenkins captained the Texas Christian University golf team for three years, once finished third individually in the Southwest Conference tournament, and won the National Golf Writers championship twice. Hogan, Nelson, and Jenkins were all once runners-up in the Fort Worth City Championship—none of the three ever won it. In 1990, Sally Jenkins was hired by *Sports Illustrated* to cover college football and golf—her Dad's old beats.

Thomas Oliver Kite, Jr.

Born: McKinney
Residence: Austin

*I can't separate it into one thing I'm proudest of
. . . I like the way most people feel about Tom Kite.*

Tension crowded out the oxygen in the air.
Strangely, Tom Kite seemed to be the only one who
was not a little short of breath.

He had bogied the last two holes, and his lead was
down to two shots. One hole left. Now Kite faced
the most intimidating shot in golf, the drive off the
eighteenth tee at Pebble Beach—with the 1992 U.S.
Open on the line.

Harvey Penick sat at home in his wheelchair, his
hands clasped tightly in his lap, his sad, wise eyes af-
fixed to the television screen. He watched his hard-
est-working student march up to the final tee, head
up, with an almost military stride, so like Tommy.
If only he could win, Harvey thought. It would mean
so much.

The eighteenth at Pebble is a left-bending 548-yard
excursion along a cliff, thirty feet above the Pacific
Ocean. To the dry, right side of the fairway are trees,

bunkers, and out-of-bounds stakes. To the left is the wind-whipped water and rockbound edge of the spectacularly misnamed Still Water Cove.

What would Kite hit? Surely he would play away from the water, with a two or three iron. Perhaps he would gamble and hit a three wood. He looked at his caddy, Mike Carrick. "What do you think about a driver?" he said. The color drained from Carrick's face.

It had been a brutal day. Strong, gusty winds had come up at midday, making a difficult course almost impossible. The greens became as hard as the marble floors in a hotel lobby. The best players in the world started turning in scores of eighty-four, eighty-six, eighty-eight. Mark Brooks, Kite's playing partner, four-putted the third green. Kite three-putted the fourth for a double bogey.

But he had rallied with long par and birdie putts on the next two holes, and an incredible chip-in for another birdie on the seventh. He'd holed out with a club he'd designed himself. The back of the sixty-degree sand wedge is stamped K-GRIND.

"Tom's play on the last eleven holes was the most intelligent I've ever seen," comments M. J. Mastalir, the USGA official who followed Kite's group. "Everyone else was collapsing, complaining about the weather, but Tom had complete control of his emotions—and his game."

Wind billowed the legs of Kite's grey pants as he got set to hit. "It's a driver!" whispered the television announcer.

He nailed it. The ball knifed through the wind, out across the edge of Still Water Cove, and stopped 295 yards later, in the center of the fairway.

"Best swing I made all day," said Kite to no one in particular as he walked off the tee.

From there it was easy. He hit a 180-yard five iron for his second shot, then, from 72 yards away, the K-GRIND onto the green.

"That was the goal all along," Kite recalls. "I've built my game around my wedge play. I wanted to hit that club for my third shot."

So that was it. Despite the wind, the ocean, and the mind-numbing pressure of the moment, Kite had played the hole in his mind—backwards, from the green to the tee—before he made a swing. Golf as chess.

And the driver? Why not an iron?

"Sooner or later," Kite replies, "you've got to make a shot."

Kite "slow-rolled" his fourteen-foot putt to the edge of the hole, tapped in, and was the new U.S. Open Champion. He hugged Carrick. Shook hands with Brooks and Mastalir. Hugged his wife, Christy. "It was an unbelievable feeling," Kite says. "A combination of shock and relief."

Christy flew back to Austin with the trophy, while Tom left California for a tournament he had committed to in New York, though he was dying to return home.

On Monday, Christy got the kids off to school and drove over to the Austin Country Club, where Harvey Penick, at age eighty-seven, was giving a lesson. "I hate to interrupt you when you're teaching," Christy said, "but I have something here you had a lot to do with." Then, very gently, she put the U.S. Open trophy in Harvey's lap.

Tom Kite, the all-time leading money winner in professional golf, has won seventeen PGA Tour events as of this writing. He was the NCAA individual champion in 1972 (with Ben Crenshaw), played on one Walker Cup and six Ryder Cup teams, and won the Vardon Trophy twice. The 1992 U.S. Open was his first victory in a "major" championship.

John Marvin Leonard

Born: Linden, 1895
Died: Fort Worth, 1970

After his family, I think my father was proudest of the three golf courses he built. Marty Leonard

First would have been his wife and four daughters, then his store. His store was his life. Third was building Colonial. Tex Moncrief

He was so successful in everything he undertook, he had to be proud of it all. Ben Hogan

In 1932, Ben Hogan, a skinny, unaccomplished, impoverished assistant golf pro with a bad hook, wanted to try the pro tour. Marvin Leonard lent him the money. In 1934, at the depth of the Depression, Leonard became convinced that he should build a championship golf course in Fort Worth. The new course, as Leonard pictured it, would have the same fine-bladed, smooth-putting bent-grass greens he had played on while on vacation in Colorado and California. But bent is a northern grass; it had almost never been grown in the Southwest. Leonard could

also foresee that his new course would deserve to host a United States Open, and to stage an important annual tournament.

In all of this, Leonard proved to be spectacularly right. His $225 of seed money helped launch the career of Hogan, possibly the greatest tournament player ever. His new club, Colonial, opened January 29, 1936, was a masterpiece; it's bent-grass greens survived and thrived. Amazingly, Leonard coaxed the tradition-bound United States Golf Association into playing the 1941 U.S. Open at his five-year-old golf course. Up to then, golf's "major" major championship had never been played farther south than Chevy Chase, Maryland. And Colonial's successful staging of the last prewar Open led, as hoped, to a yearly event. The Colonial National Invitation Tournament has been a fixture on the men's tour since 1946.

"Daddy always had a desire to create something," says Marty Leonard, one of Mary's and Marvin's four daughters. "He had tremendous vision. And he could create what he could visualize."

Vision requires imagination, which is free; creation costs money. The source of the Leonard fortune was the Leonard Brothers Department Store. "A no. 2 tub of dried beans that you scooped into a paper bag, a slab of bacon, and a pair of scales that probably slanted towards the house. That's how Leonard Brothers started," according to Berl Godfrey, Leonard's longtime friend and Colonial's first president. Marvin first opened his modest store in December, 1918; brother Obie joined the enterprise a year later. Within a decade, the store was a huge success, a Fort Worth institution. Marvin and Obie, from little Linden in East Texas, were rich.

"Marvin Leonard had a grasp for what could be," says writer Russ Pate, who studied Leonard's life and times for his Colonial Country Club history *The Legacy Continues.* "He invented the superstore. He had Wal-mart thirty years before Wal-mart."

In 1927, Leonard's doctor ordered his overworked patient to get out of the store and get some fresh air and exercise. Leonard's daily nine holes of therapy became an obsession. He played at Glen Garden Country Club, where he occasionally employed a quiet, determined-looking caddy named Ben Hogan.

The merchandising genius and the caddy/assistant pro would eventually become business, golf, and gin-rummy partners. Was Hogan the son Leonard never had? Was Leonard the father Hogan lost in his youth? "My father treasured his friendship with Hogan," says Marty Leonard.

"Marvin Leonard was my best friend," says Hogan.

At the Marvin Leonard Appreciation Dinner at Colonial in 1969, Hogan recalled for the large audience how his old friend helped him get on the tour. "And when it came time for me to pay the money back to him," said Hogan, "he said, 'Ben, you've done me a great favor. I just wanted you to ask. You couldn't pay me five cents.'"

There is a picture in Russ Pate's history of Colonial of Hogan accepting the Marvin Leonard Trophy from Leonard himself, for winning the first Colonial NIT. The two men are grinning at each other, not at the trophy or at the photographers in front of them. The look of joy on their faces is profound.

Marvin Leonard and his brother were honored by the Fort Worth Exchange Club as "Outstanding Citizens of Fort Worth for 1961" for their public philanthropy and private charity. Leonard built three Fort Worth golf courses: Colonial, Shady Oaks, and Starr Hollow.

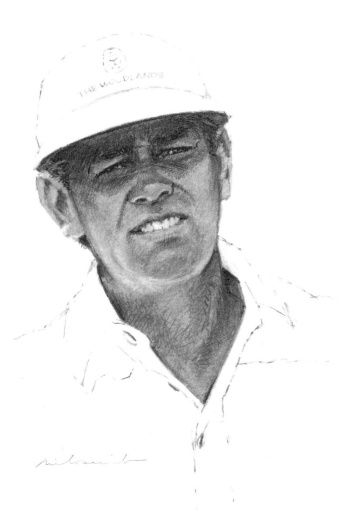

John Drayton Mahaffey

Born: Kerrville
Residence: Houston

Winning the PGA was definitely my biggest thrill.

Sparks fly up from the grinding wheel and disappear before reaching John Mahaffey's sweating face. It's midsummer, 1977, and the pro tour is where, Atlanta? Washington?—but Mahaffey is at home, alone, tinkering with his golf clubs. He clicks off the grinder, takes off his safety glasses, and examines his work. Then he puts down the club and rubs his left elbow. Feels a little better today.

Inactivity is driving Mahaffey crazy. He can't play golf because of the tendonitis in his elbow. And since he can't play golf, about all he can do is work on his clubs. And think about how he should have won the last two U.S. Opens.

"I hit sixteen of eighteen greens in regulation in the playoff in '75—and didn't make a birdie," recalls Mahaffey disgustedly. "I putted like an idiot." Lou Graham won; he shot seventy-one to Mahaffey's seventy-three. The two had tied after four rounds at Medinah Country Club in Illinois.

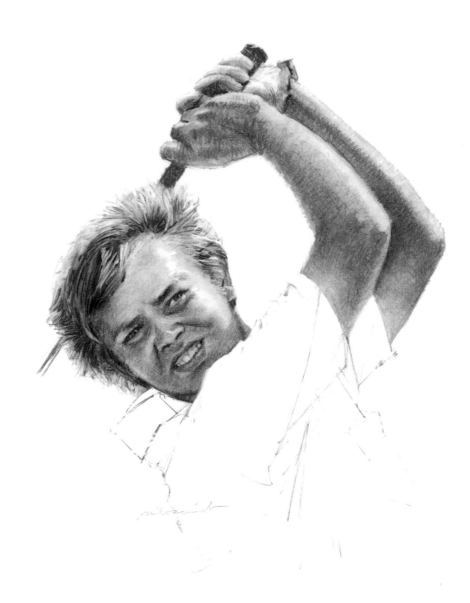

Mahaffey was the victim of Jerry Pate's miraculous 193-yard five iron shot and tap-in birdie on the final hole of the next U.S. Open at Atlantic Athletic Club. It's another bitter memory: "I'd led the tournament for sixty-eight of the seventy-two holes, but I'd just bogied sixteen and seventeen [in the final round] and Pate had gone ahead. On the last hole, my ball was just off the fairway in a horrible lie. But Pate's lie was perfect from thirty yards off the fairway."

Mahaffey, hitting first, gazed at the lake in front of the narrow green, 210 yards away, peered down at his ball, nestled like a marble in a shag carpet—and decided to go for it. It didn't work. "I tried a dumb shot—tried to skip it through the water [the ball stayed in the hazard]. I just wanted to win. I'd been second before."

Tivy High School's greatest athlete was a wiry, competitive little guy from the class of '66. John Mahaffey was 5-foot-8, 145 pounds, not very strong or fast, but every Kerrville fan knew him and every boy in the little town wanted to be like him. "If someone told me I couldn't do something, like track or football, I'd just do it," Mahaffey says.

His best games were basketball and golf, and he received college scholarship offers in both sports. But he always had wanted to be a professional athlete. The teenage Mahaffey noted that his physical dimensions were much nearer Ben Hogan than Wilt Chamberlain; he chose golf. And golf chose him. Dave Williams, coach at perennial NCAA champion University of Houston, saw something he liked in the kid from Kerrville and offered him a scholarship. Mahaffey, thrilled, accepted.

Mahaffey's scholarship was a loan, not a gift; if he failed to finish in the top six in the qualifying tournament Williams held every semester—no scholarship. There were literally dozens of good players competing for UH golf student aid. "Not everyone thrived in that situation, but I liked it," Mahaffey says. "It toughened me up."

He won the NCAA Individual Championship his senior year, turned pro, and was an almost immediate success. Mahaffey is what the pros call a "grinder"; he concentrates and competes fiercely, and rarely misses a fairway or a green. His swing is not classic or pretty, but it is very effective on long,

tight courses—like the ones they play in the U.S. Open or the PGA Championship.

Mahaffey was finally healthy and back on the tour in 1978. He felt so good, in fact, that he was able to shoot sixty-six in the final round of the PGA at Oakmont Country Club, good enough for a tie with Tom Watson and—hello, again—Jerry Pate. It was finally Mahaffey's turn: he made a heart-stopping, ten-foot downhill putt on the second play-off hole for a birdie and the win. Then he raised his arms in triumph.

John Mahaffey has nine career victories on the tour, including the 1978 PGA. He played on the 1979 Ryder Cup team and was the 1970 NCAA champion.

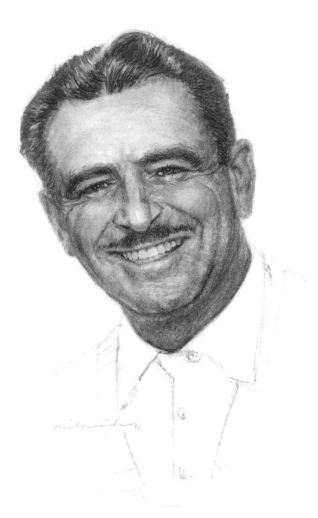

Lloyd Eugene Mangrum

Born: Trenton, 1914
Died: Apple Valley, CA, 1973

When the shooting was finished and we were able to play in the European Theater Championship at St. Cloud Country Club near Paris, that was a greater thrill than ever experienced before [sic] . . . I had the good fortune to win . . . there couldn't be any first prize money in any tournament that could mean as much to me. Lloyd Mangrum, "My Greatest Tournament Thrill," in the official program of the 1946 Fort Worth Open.

Of the top golf pros of the World War II era, only Lloyd Mangrum saw combat. While Ben Hogan, Jimmy Demaret, and Sam Snead fulfilled their military obligations stateside (Byron Nelson, a hemophiliac, was 4-F), Mangrum was an army corporal stationed in Europe. He fought in the Normandy Invasion, otherwise known as D-Day. "After four major battles," wrote Charles Price in *Golf Digest* (October, 1990), Mangrum "and another man remained the sole survivors of their original platoon, which lost five different lieutenants." Mangrum

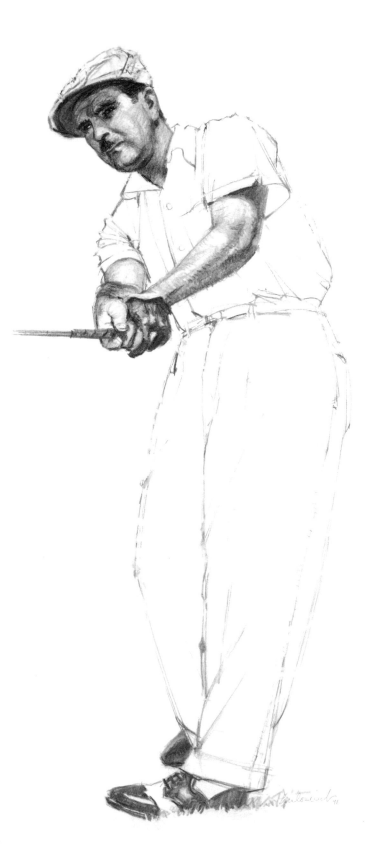

was shot through the leg and on the chin and broke bones in his shoulder and upper arm. FOR MILITARY MERIT is inscribed on the back of the two Purple Hearts he won.

"I don't suppose that any of the pro or amateur golfers who were combat soldiers, Marines, or sailors will soon be able to think of a three-putt green as one of the really bad troubles of life," wrote Mangrum after the war.

Combat had given him perspective; did it also harden him? Perhaps. But there is evidence that even before the war, Lloyd Mangrum was a slightly reclusive man, a flinty, unyielding competitor in golf and in life.

He went to work for his brother Ray, the head professional at Cliff-Dale Country Club in Dallas, at age fifteen. Janitor, caddy master, assistant pro—Lloyd did anything that was needed so he could hang around the golf course and work on his game. He never played in an amateur tournament; he was a pro from the start.

After several years of this, Mangrum moved, by himself, to Los Angeles. There his daily bread was won—or lost—through gambling on his golf and gin rummy games at the local municipal courses. At age twenty, he married a widow with three children. Then he joined the tour and barely supported his family for the next six years.

There is a picture of the 1941 Ryder Cup team—the match was never played, canceled by World War II—that seems to reveal something about the twenty-seven-year-old Mangrum (he had finally started to win in 1940 and 1941 to make the elite squad). It was a great team: there is Byron Nelson, open-faced and smiling; Gene Sarazen, arms crossed, cocky; non-playing captain Walter Hagen, a regal tilt to his head; and affable looks on the faces of Sam Snead, Ben Hogan, Jimmy Demaret, and Horton Smith. Only Mangrum, seated between Sarazen and Craig Wood, appears guarded. He looks like he's giving the camera a sizing-up, as though he were deciding whether to call the bet, or raise.

The gambler image was enhanced by Mangrum's trademark pencil-thin moustache and his addiction to nicotine. "He was a real cool cat on the golf course," Nelson recalls. "He played with a cigarette hanging out of the corner of his mouth. And he was a wonderful putter."

Jack Burke, Jr., was impressed with Mangrum as a competitor: "He was tough, unrelenting, exactly like Hogan. He'd burn your ass."

In the 1946 U.S. Open at Canterbury Country Club in Cleveland, Nelson, Vic Ghezzi, and Mangrum tied for the title after four rounds. All three shot seventy-two in the play-off the next day. In the sixth round of the marathon, Mangrum fell two behind after eight holes, then hit a ball out of bounds on the ninth. But he made a seventy-five foot putt to save a bogey on nine, then birdied the thirteenth, fifteenth and sixteenth holes. Mangrum, the great competitor, won.

In the 1950 U.S. Open at Merion, Mangrum was in another play-off, this time with George Fazio and Hogan. He was just a shot behind Hogan when, without thinking, he picked up his ball on the sixteenth green without marking it to shoo a bug away. Two stroke penalty on Mangrum; Hogan won. "Fair enough," the cool cat said afterward, "we'll all eat tomorrow, no matter what happens."

Bill Crummer, a business executive from Hudson, Ohio, caddied for Mangrum in 1946 at a tournament in Chicago. "I had yardages and knew where all the pins were cut, but Mangrum didn't want any of it," Crummer says. "He was just a real quiet guy. He had his own ideas on how to play." Thad Johnson, who wrote about Mangrum for the Texas Sports Hall of Fame, takes Crummer's comments a step further: "[he had] a firm dislike for public handshaking, interviews, and talking, period."

Mangrum, writes Price, was "the last of the tough guys."

Lloyd Mangrum ranks sixth on the unofficial historical ranking of PGA players. He had thirty-six career victories, including the 1946 U.S. Open, won the Vardon Trophy in 1951 and 1953, and was on the Ryder Cup teams of 1941, 1947, 1949, 1951, 1953, and 1955 (captain in '53 and '55).

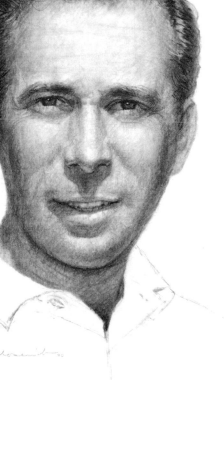

David Francis Marr, Jr.

Born: Houston
Residence: Houston

I'm proudest of being named captain of the Ryder Cup team in 1981. I mean, that was an honor. I cried like a baby.

Dave Marr has a cigarette in his left hand, a coffee cup in his right hand, and a smile on his face. He is sitting in the press room at the 1990 Byron Nelson tournament as friends he hasn't seen for a while pass by.

"What ever happened to Dave Marr?" joshes one old buddy, extending his hand.

Marr shakes the hand and answers solemnly: "He wanted to get away from pro football. So he moved to Dallas." There are guffaws all around, especially from Marr.

Marr, the 1965 PGA champion and the color analyst on ABC golf telecasts for almost twenty years, has been a success in both golf and broadcasting. "I've been thinking about this a lot lately," he says, stubbing out a Merit Light. "I've led a privileged life.

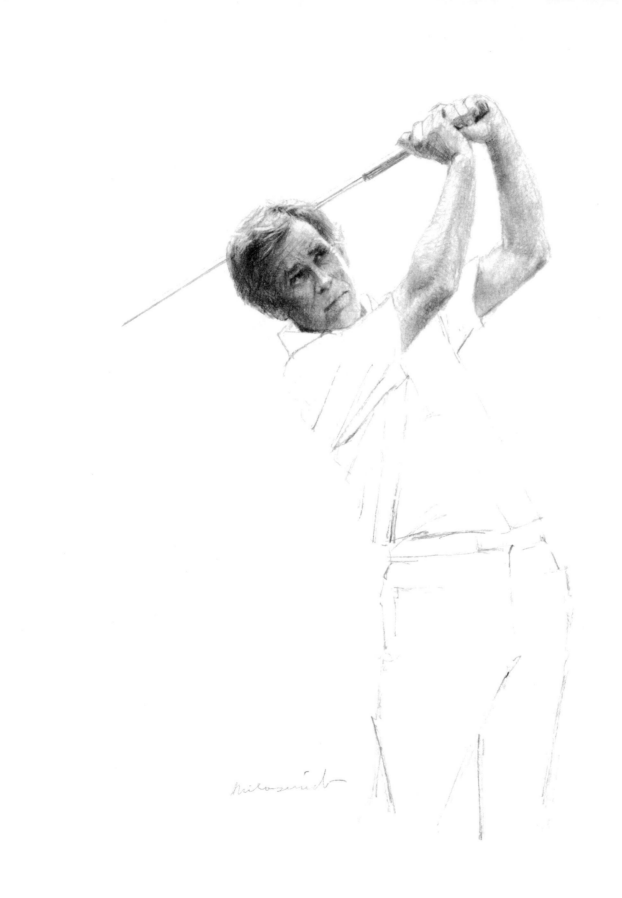

84

I've been blessed with people who have helped me. My life has been wonderful.

"You think that guy out there sweeping the floor thinks I work? To him, I don't hit a lick."

Marr is the son of a Baytown, Texas, club professional. He developed his game at one of Houston's municipal golf courses, Memorial Park. "Sure, we played for money. I could afford to win, but not to lose," he laughs. "I learned to trust my swing—and to play even, no handicaps—even against better players. Those matches back then were our U.S. Open." His cousin, Jackie Burke, Jr., and Jimmy Demaret—Marr heroes to this day—occasionally deigned to tee it up with the teenager. All doubt was removed; golf would be Dave Marr's life.

He turned pro in 1953. "There was no money on the tour then. I just wanted to get my Ph.D. in golf with a good club job." Jack Burke, Sr., the pro at River Oaks, helped him get what he was looking for: an assistantship to Claude Harmon, one of the country's top golf instructors, at prestigious Winged Foot, in New York.

A victory in a major golf championship means a permanent name change for the victor. Bill Rogers was just another William until his handle was changed to "1981 British Open Champion Bill Rogers." B.D. Crenshaw of Austin was thrilled to become "1984 Masters Champion Ben Crenshaw." So too, for Dave Marr; his win at the 1965 PGA Championship changed his name—and his life.

"I was in the middle of a good streak," Marr recalls. "I'd been playing well for five weeks and was able to keep the same thoughts, the same concentration, in the PGA." He won the tournament by two shots over Billy Casper and Arnold Palmer.

Marr had been an upper-middle-class player since joining the tour in 1960, but now, his engaging personality, his humor, and his bright mind gained a wider exposure and seemed somehow more vivid. He was, after all, *PGA Champion* Dave Marr.

As his golf career began to wane in the early 1970s, Marr was approached by ABC Sports president Roone Arledge, an old friend from Winged Foot. "We're thinking about expanding our golf coverage. Are you interested?" Marr thought about it. Arledge came back: "You've got to make up your mind what you're going to do."

Said Marr: "You've got to make up your mind what you're going to pay me."

Marr became a fixture at ABC and then the BBC. His broadcasting style is relaxed and funny, yet respectful of the game and its players. Most sports announcers seem to be describing Armageddon; Marr keeps it light. Other golf analysts take pains to be irreverent ("Nice shoes, Smith") or blunt ("That was a dismal stroke by Jones"): Marr criticizes rarely.

"That's the way I am," Marr says. "I would never say someone 'choked.' Who am I to say something that the player has no chance to rebut? That's unfair. And you can hurt people by saying something you think is funny."

Marr takes a sip of coffee. "Golf is not a matter of life and death. It's more important than that," he says. Then laughs.

Dave Marr won four PGA tour events, including the 1965 PGA Championship. He was a member of the 1965 Ryder Cup team and was captain of the 1981 team. He is a member of the Texas Golf Hall of Fame.

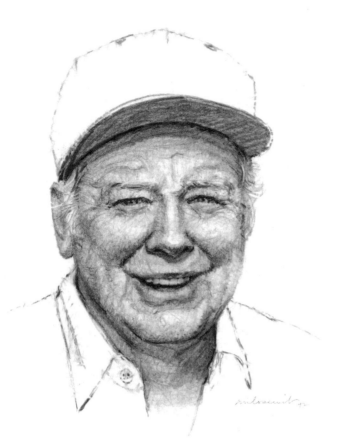

Billy Joe Maxwell

Born: Abilene
Residence: Jacksonville, FL

I'm just proud to be able to play today.

Billy Maxwell's small, square strong hands won't stay still. "He's short fused. He's not a detail man," his wife, M. K. (Mary Katherine) has warned. "Billy thinks five minutes is five hours."

Maxwell fidgets while he explains how he got interested in golf. "My dad, W.O. Maxwell, was greenkeeper at Willow Creek Country Club in Abilene [the course has been renamed Maxwell Municipal in the elder Maxwell's honor]. My twin brother Bobby and me just took it up. Golf was just the only thing to do. What else would I be? I always wanted to be a golfer. I never wanted to be a banker. I'm like Trevino; a day off for me is a day of golf with my friends."

Like many of the best golfers of a generation or two ago—Ben Hogan, Byron Nelson, Billy Casper, and scores of others—Maxwell learned the game as a caddy. "I'd look for the best player when I was caddying in the Abilene Invitational at Abilene Country

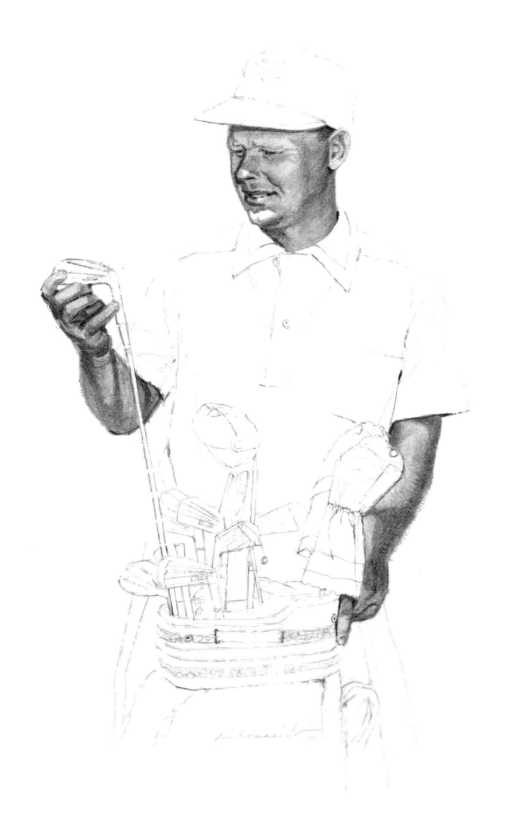

Club, then copy his swing," Maxwell recalls. "That would be my swing for the year—until the next Invitational."

Don January, an old friend and golf teammate at North Texas State, says the young Maxwell "was one of the best amateurs I ever saw. He was wonderful with the middle and short irons." January smiles. "'Little Mother.' I never beat the little shit, at least not in head-to-head match play."

Maxwell won the 1951 United States Amateur at Saucon Valley Country Club in Bethlehem, Pennsylvania, but is vague now about who he played. "I know I beat Gene Towry [another member of the NTSU national champion golf team] along the way, and I think I played Joe Gagliardi—he's a federal judge in New York now—in the finals. I was just a young kid who kept winning. I didn't have a reputation like some of the others. But when I got on the golf course, I was gonna beat whoever-the-hell was out there."

Billy Maxwell played on three National Collegiate Athletic Association championship teams at North Texas State, won six times on the PGA tour, and was a member of the 1963 Ryder Cup team. Today he plays on the senior tour. He loves it. "It's like being reborn again," Maxwell says.

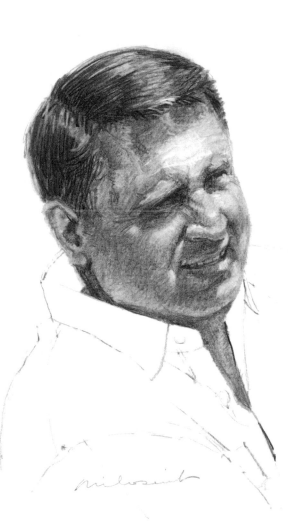

Rives Russell Mcbee

Born: Denton
Residence: Irving

There are several things I'm proud of, including putting together our tournament benefitting muscular dystrophy and helping keep our [North Texas] junior program going.

You probably first heard of Rives McBee when you opened the sports page of your newspaper one Saturday morning in June, 1966. "Palmer, Casper Lead U.S. Open" the headline read. Below that: "Unknown McBee Shoots 64, New Open Record."

Holy mackerel, sixty-four, you thought, as you read: "McBee, 28, a Midland, Texas assistant pro, teed off at 7:00 a.m. and posted his course and tournament record score before most of the field had even arrived at the Olympic Club. McBee is tied at 140 with Phil Rogers of San Diego . . . they trail Palmer and Casper by three going into today's third round . . ."

McBee had played in solitude and anonymity in the first two rounds, but in round three, recalls McBee, "There was Johnny Miller and Jack Nicklaus in front of me, and Billy Casper and Arnold Palmer

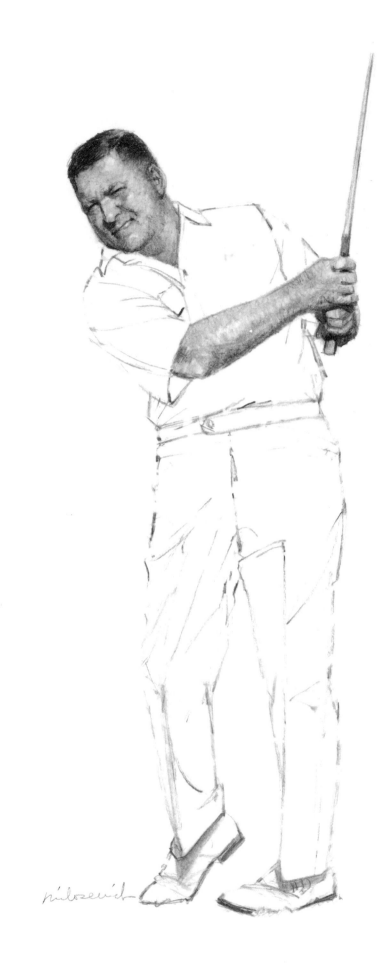

90

behind me, and a gallery of twenty thousand. I got to know what the tunafish in the middle of a sandwich feels like." Though feeling tense and surrounded, McBee also felt determined to show that he belonged in this company. "Everybody had made remarks about U.S. Open one-day wonders, predicting I'd be skying into the eighties," he says. Despite the pressure and the predictions, he shot a respectable seventy-four— "I'm as proud of that seventy-four as of the sixty-four," McBee says—and remained in contention until the final nine holes of the tournament. He finished thirteenth. And wasn't heard from again for twenty-five years.

McBee led a hand-to-mouth existence on the pro tour for several seasons after his big splash in the Open, then returned to the club professional business in Dallas until 1988. But his love for competition on the highest level was unrequited. Thus he found himself on the Senior PGA Tour the moment he turned fifty.

One weary night in 1989, on a trip from the last tournament to the next one, McBee looked out his airplane window and saw his orange PowerBilt golf bag on a luggage cart. Then he felt the plane leave the gate. "Ma'am, it doesn't do me any good to leave without those clubs," he sang out to a flight attendant. McBee arrived in Lexington, Kentucky—with his clubs—at one a.m. It had been an eight-hour trip from Albuquerque. After a few hours sleep, he found his way to the golf course and shot sixty-seven, the low round of the qualifying for the event. Then, on rounds of sixty-eight, sixty-five, sixty-nine, he won the tournament.

A month later, McBee contended again, but finished second by a shot to Gary Player. "Someone asked me afterward if I was disappointed," McBee says. "Disappointed? I'm living a childhood dream."

Rives McBee won the 1973 National Club Pro championship and played on four PGA Cup teams. He has won three Senior Tour events as of this writing.

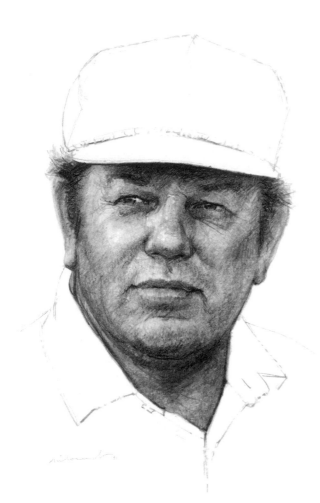

Orville Moody

Born: Chickasha, OK
Residence: Sulphur Springs

The Open.

Orville Moody sits in a lime-green upholstered chair in the airy, brightly lit Terrace Room at Shady Oaks Country Club. Shady Oaks is Ben Hogan's club. And there is Hogan himself, over by the window, talking with Gene Sarazen. Sitting with Moody are Sam Snead, Billy Casper, and Gene Littler. This august company—Chi Chi Rodriguez, Bob Toski, and Doug Ford are also on hand—is gathered to have its picture taken. A Japanese company, which will use this photo day to promote its new golf resort, is picking up the tab. "The money's fantastic," Sarazen confides. The Japanese are calling their new course (surprise) "Legends."

Based on their records on the PGA tour, Moody seems at best a marginal qualifier for this group. He won exactly one PGA Tour event. Snead, on the other hand, won eighty-one times; Hogan, sixty-three; Casper, fifty-one; Sarazen, thirty-seven; Littler, twenty-nine; Ford, eighteen. But there is this golf

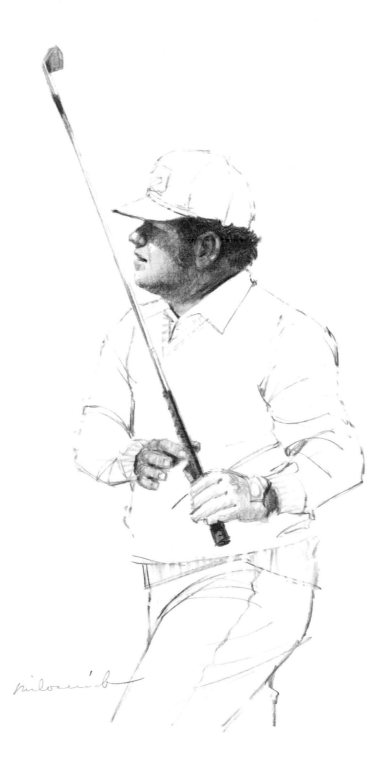

93

club called the long putter and this thing called the Senior PGA Tour; Moody used the one on the other to win two tournaments and $647,985 in 1989. On this dreary winter day in 1990, Moody is the best senior player in the world—and in the room.

"Long putters" are about fifty inches long (versus the traditional length of about thirty-six inches) and are used in a pendulous stroke, as though you are tapping a rock with a garden rake. Moody is the acknowledged master of the club.

"I think that putter ought to be outlawed. Or send him [Moody] back to the regular tour," says Littler. The burly, round-faced Moody smiles.

"I'm going to try the long putter. It will be my last hurrah," says Snead. "I've got four of them at home I'm trying. Orville, is your putter heavy?"

Moody, an unpretentious, affable man replies that yes, his putter is heavy. He is asked why some people have advocated banning clubs with extra-long shafts. "The case against long putters? They say it's not a stroke . . . but it's more of a stroke than with the traditional putter. And they don't like that you hold the long putter against your body. But Billy [gestures toward Casper] anchors his putter against his leg. So what's traditional? Steel shafts aren't traditional. Wooden shafts are."

Moody sighs. "Well," he says, "if they did outlaw it, I'd just go back to the back of the pack."

Ex-Army sergeant Moody had been on the tour two years and was just getting by. He could hit the ball as well as anyone from day one, but his putting was an embarassment. Even putting cross-handed, his wrists were so flippy and his stroke was so yippy that no putt, no matter how short, was ever a sure thing. "I was always nervous over those short putts," he says. "I'd get all tied up. It was like an electrical shock. I absolutely had no confidence at all."

Moody, then thirty-five, was not invited to play in the 1969 U.S. Open at Champions Golf Club in Houston. He had to submit to the thirty-six-hole qualifying tournament; he holed a bunker shot on the thirty-fifth hole to qualify by one.

The day before the first round, a reporter asked Lee Trevino, the defending champion, who was going to win. "Orville Moody," Trevino answered. "He's a helluva player." Orville who? the writer wondered. You mean that guy who can't putt? But Trevino knew the tour's worst putter was perhaps also the best ball striker in the game.

With four holes to play, five players had a chance to win: Al Geiberger, Deane Beman, Bob Rosburg, Arnold Palmer—superb putters all—and Moody. But form didn't hold. First Geiberger, then Palmer, then Rosburg missed critical short putts, while Moody, with elegant tee to green shots and a horrible-looking scrape of a putting stroke, prevailed. "Orville Moody winning the 1969 U.S. Open was a bigger shock than Sam Parks's winning in 1935," wrote Robert Sommers in *The U.S. Open: Golf's Ultimate Challenge*. Sam Parks was a *club* pro.

Talk about coming full circle: Moody faded off the tour a few years after his only victory—couldn't putt. Now he wins over a half million dollars a year, and people like Snead and Casper listen when he talks—about putting.

Orville Moody also won the World Series of Golf in 1969, then an "unofficial" tournament. He has twelve Senior Tour victories as of this writing and was the 1958 All-Army and 1962 All-Service champion.

Gus Turner Moreland

Born: Lancaster
Residence: Conroe

The family first. I stopped my golf career to get married, so you know I was thinking family before golf. My biggest thrill in golf was being named to the Walker Cup team in 1932, two weeks before the matches were played.

Gus Moreland had two nicknames. "Gus the Walker" referred to his habit of strolling along with the putt he had just hit, to facilitate the early removal of ball from hole. When Moreland walked after a putt, he knew he'd made it. It was a supremely confident gesture, infuriating to his opponents. "When Gus Moreland got that putter going, he was unstoppable," recalls Betty Jameson. "He was the most remarkable putter I ever saw."

Moreland's other nickname was "Victrola." This moniker is still apt; he talks in a loud, clear voice despite his eighty years and requires no prompting to tell story after story, or describe round after round. Flick a switch, put the needle on the record, and the Victrola is on: "OK, so I'm two down now and he says

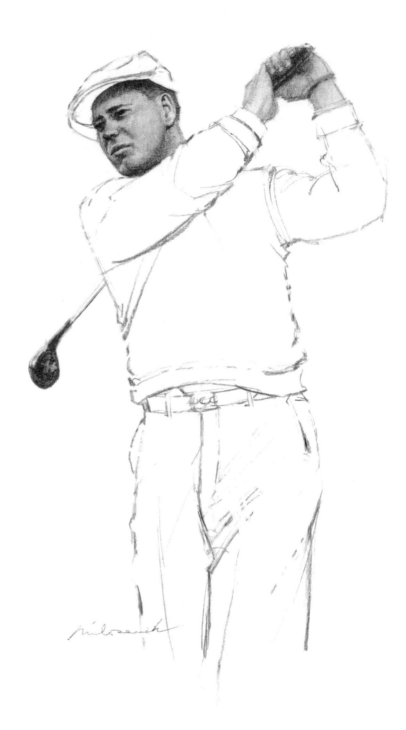

96

'who's away' and we're about even so I said 'I'll go ahead if that's ok,' so I hit it about six or seven feet and he hit it about twenty feet. Well, he missed and I made it so now I'm one down. On the next hole I'm under a tree . . . " The effect is numbing.

If you didn't know this competitive, garrulous man was a golfer, perhaps the best amateur in Texas history, you would guess that he was a salesman. He was. Moreland, in fact, gave up golf for a sales job in 1934. He was twenty-three and in his young career had beaten Byron Nelson, Ben Hogan, Ralph Guldahl, Lawson Little, Francis Ouimet, and several other of the best players of the day. Then he abruptly left the international golf scene to go to work for the Fleming-Potter Lithograph and Printing Company of Peoria, Illinois. Moreland explains:

"I was on my way back from the Walker Cup in England when I decided to play in the Western Amateur in Peoria, even though I was a little tired and homesick. A fella invited me to dinner; he was going to start a lithograph printing business—he wanted to print the Walker whiskey labels—and he wanted someone to play golf with important customers and be a salesman.

"Gosh, they only made one hundred or two hundred dollars when they won on the tour back then. I had to decide if I wanted a pro career or wanted to get married when I found the right girl and raise a family. I decided I wanted a wife and a family."

Moreland got the wife (Marion, from Peoria), family (five children), and career (twenty-eight years with Fleming-Potter) he wanted. No regrets: he tells stories of his successes as a salesman with the same relish that he recounts his match-play wins over Nelson and Hogan. These tales have a recurring theme: someone said Moreland couldn't do something, so he did it. Whether it was his success in a golf tournament, wooing and winning his spouse, or landing a big order for his employer, Moreland always saw himself as the underdog succeeding against long odds.

Moreland grew up around Stevens Park golf course in Oak Cliff, near Dallas. He caddied for his stepfather, who rebuffed little Gus when he asked if he might join the foursome as a player sometime. "'No, we are too good for you, you'd better stick to carrying my bag,'" Moreland quotes his stepfather.

The day came when Gus was allowed to play; he shot forty-three and beat two of the foursome's regular players. "They never invited me to play again," Moreland says.

Before his match with Ralph Guldahl in the semifinals of his first big tournament, the Southwestern Amateur, Moreland recalls overhearing a man predict the tournament outcome. "'Guldahl will be in the finals, as he's playing someone he's been beating,'" Moreland says the man said.

His companion replied, "'Yes, you're right, but Hogan will get the silver tea set [first prize].'"

Moreland felt compelled at this juncture to introduce himself to the men. "I told them I would be the winner of the tourney, and they could come to the dinner to see me get the silver tea set." Moreland beat Guldahl in the semifinals and Hogan in the finals.

Could Moreland have continued to beat Nelson and Hogan, Little, Guldahl, and the others, as a professional? Perhaps. But what is certain is that for a while in the early 1930s, he did beat them. Gus Moreland was among the best of his day.

Gus Moreland, a member of the Texas Golf Hall of Fame, won the Western Amateur, The Trans-Miss twice, the Texas State Amateur three times in a row ('31, '32, and '33) and the Mexican Amateur. He was also an unbeaten member of two Walker Cup teams.

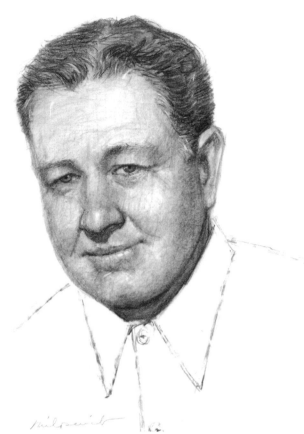

John Byron Nelson

Born: Waxahachie
Residence: Roanoke

I was in the money in 113 consecutive tournaments, which proved I was consistent mentally and physically . . .

No, I don't remember the 114th tournament. It must have been when I quit in August, 1946.

Byron Nelson, a precise man, can read upside down words and numbers. "No, the first Byron Nelson Classic was in '68, not '67," he says, correcting a writer's scribbled note. "I'd been involved with the Salesmanship Club [a Dallas charity], and they asked me in 1967 what can we do to improve our tournament? The Dallas Open was floundering around then with various sponsors. I answered that you must have something that will tie everything together for the whole community."

The charity suggested that Nelson himself could unite Dallas and Fort Worth behind the tournament. Nelson agreed; the renamed event has been a fixture on the tour—and a Dallas institution—ever since.

Tournament week is chaos, hubbub, and plain hard work for Nelson. He is eighty years old now, but still he accommodates everyone who tugs on his sleeve for an audience, an autograph, or an interview.

"I can only give you a few minutes." Nelson says. He limps slowly, painfully to a chair and sits the way pregnant women and people with arthritis sit—with force and visible relief. "My hip hurts all the time," Nelson admits. He needs surgery—the hip joint needs to be replaced with an artificial one—but that will wait until after "Nelson Week."

It's this very accessiblity that forms one of the pillars of the Nelson legend. He wants to help—whether you are a fan, a tournament volunteer, a

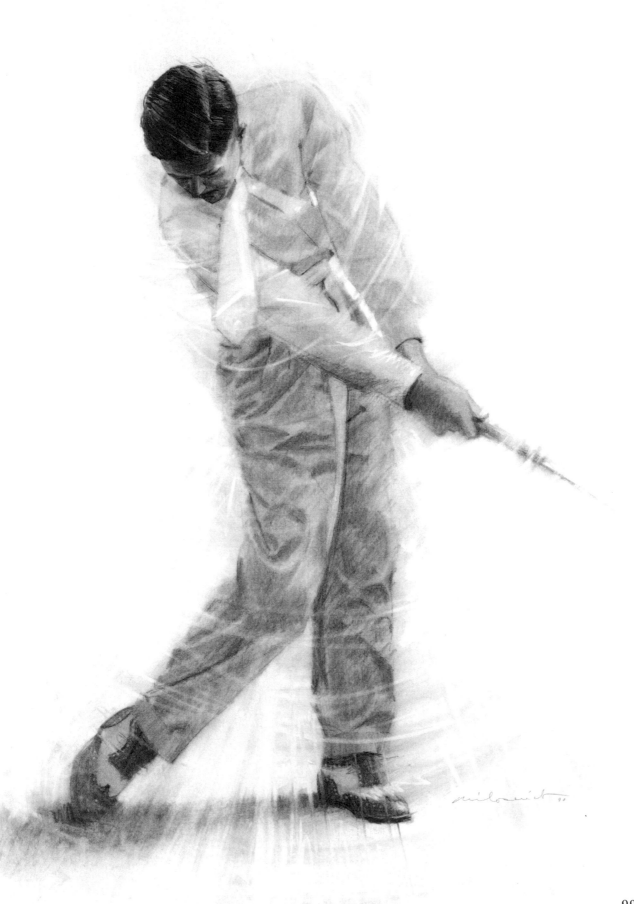

writer—or a golf pro in need of encouragement. Player of the Decade Tom Watson, Nelson's most famous protégé, is a member of the latter group.

"When I was a kid," the articulate Watson says, "my father was always quizzing me about golf records. 'Who won the most tournaments in a year? Who won the most tournaments in a row?' The answer is Byron Nelson, of course. So I was aware of him from an early age.

"At the '74 U.S. Open at Winged Foot, I was leading—then I shot seventy-nine in the final round [and lost]. I was commiserating in the locker room with John Mahaffey afterward. Then Byron came up—he was working as a TV analyst for ABC—and said 'I'd like to talk with you for five minutes. I like your swing and I like how you handle yourself. Anytime you want to come to Texas, I'd like to work with you.' Two years later, I took him up on it.

"It's impossible to tell you all the mechanical things we worked on. Most of all, he was very positive. 'That's good—now you've got it,' he'd say."

Watson's already good game picked up dramatically. He was Player of the Year six of the next eight years following his initial session with Nelson.

"Byron is a close friend and father figure to me," says Watson. "He goes out of his way to be nice to people and to help the game of golf. It's an old cliche, but Byron Nelson has really given a lot back to the game."

Nelson raises his hand in a "just a minute" gesture to his wife Peggy and someone from the tournament committee. He is recalling his youth. "I came up in the height of the Depression," he says. In the mid-1920s, the Nelsons moved from their cotton farm in Ellis County, just south of Dallas, to another farm in Fort Worth. There Nelson got his first exposure to golf, as a caddy at a nearby private club, Glen Garden. He joined another skinny Fort Worth teenager in the Glen Garden caddy yard, a tough-looking kid named "Bennie" Hogan.

"I learned golf just for the love of the game. I wasn't thinking about the tour," Nelson recalls. Indeed, there wasn't much of a tour to think about. He went to work as a file clerk for the Fort Worth and Denver Railroad, got laid off in 1932, and started to play golf for a living.

"There was nothing else to do," Nelson says. "There weren't any jobs . . . the only thing was, I loved to play." Nelson became a rich man in his very first tournament. He finished third at Texarkana and won seventy-five dollars. He bought a Model A roadster and joined the tour.

"I started playing with hickory shafts, but right about then, in the early thirties, I switched to steel," Nelson says. "I got a reputation as a good steel-shaft player." By the late 1930s and early 1940s, golf insructors and other players were dissecting and imitating the powerful, functional Nelson swing. This was a golden age in golf, the era of Nelson, Hogan, and Sam Snead, the American triumverate. But it ended abruptly in 1946. Nelson retired.

Opera buffs call Luciano Pavarotti's tenor "The Voice." Golf historians refer to Byron Nelson's unparalleled period of sustained excellence in 1945 in a similar, simple manner; "The Streak."

Nelson's eighteen-hole average during The Streak was 67.5; his average for the year was 68.3, a record. As Tom Watson recited to his father thirty years ago, Byron Nelson won the most tournaments ever in one year, eighteen. Byron Nelson won the most tournaments ever in a row, eleven. *Eleven.* The second best consecutive-win streak, which is considered unapproachable today, is held by Jack Burke, Jr.: he won four in a row in 1952.

"Yes, I'm proud of the consecutive-win streak, as far as records go," Nelson says, "because it proved my swing was repeatable, and it proved I never stopped trying."

Now Nelson really must go. He rises gingerly to his feet. Could I possibly call you, his guest asks, some questions I . . .

"Anytime. 214-555 . . ."

Byron Nelson won fifty-two PGA tour events, including twenty-four in 1945 and 1946. He played on four Ryder Cup teams; won the Masters in 1937 and 1942, the 1939 U.S. Open, and the PGA Championship in 1940 and 1945. He won the Vardon Trophy in 1939 (because of the war, the award for the lowest stroke average was not given in 1945). He is a member of the PGA Hall of Fame.

Harvey Morrison Penick

Born: Austin
Residence: Austin

You're asking me to brag and I don't want to do that.

Harvey Penick is old and ill and frail and smarter than me. He sits in a white-canopied golf cart at Austin Country Club, a clipboard in his lap; he is nominally the tenth tee starter, but he is much more talisman and sage than club employee.

Dave Marr calls him "one of God's people." He is indeed a gentle man, this patriarch of Texas golf, but he is also humorous and sly. "I'd like you to meet Mr. Ammanex," Penick says, as a confused-looking member introduces himself as Roane Puett. Ammanex? "Well, whenever I see you, you say 'Am I next?'" explains Penick. HOW ARE YOU TODAY, MR PENICK? asks another member, loudly, compensating for the old gentleman's hearing loss. "I'm *Mister* Penick's son, Harvey," he deadpans, not answering the question. He confides later that he is in considerable pain, mostly from the arthritis which cruelly bends his spine. "I got up at five this morning, but

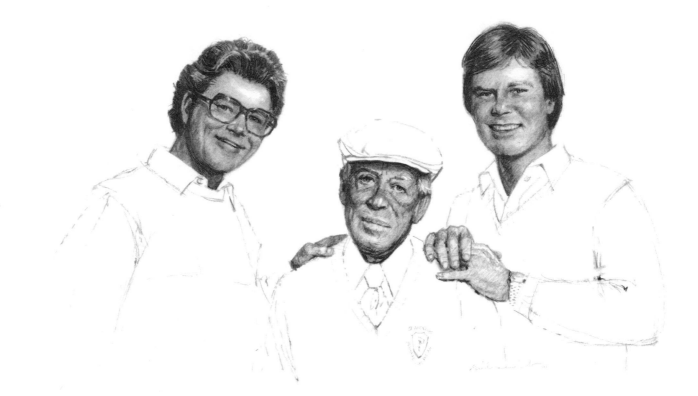

102

couldn't make it to the bathroom until six. I couldn't move," he says softly.

The man who taught Tom Kite, Ben Crenshaw, Kathy Whitworth—and hundreds of others—to play golf was the head professional at Austin Country club for sixty years. For thirty-two of those years, he doubled as coach of the University of Texas golf team. "I've been teaching since I was eighteen," Penick says, but there was a time when he aspired to be a great player.

"I qualified for the U.S. Open at Olympia Fields, in Chicago [in 1928]," he recalls. "It was the first time I was a long way from home. I saw Walter Hagen hit that ball like a bullet. He had the biggest gallery I ever saw. I didn't play very well. Coming home on that slow train, I thought, man, I better stick to teaching."

So golf instruction became the focus of Penick's life. Beginners, professionals, and those in between flocked to him for his insight, encouragement, and gentle persuasion. "I always said, when I quit trying to learn, I'll quit trying to teach," he says. Penick, unlike most instructors, is not rigid or doctrinaire; he has no "system."

"Someone wanted to know how I can talk to Kite, then to Crenshaw fifteen minutes later. Those two are as opposite as day and night. Well, there is no set way to teach.

"I let players move off the ball more than most pros. If you don't move your head, you can't play. I also like a hook. I think golf is much more fun with a hook than a slice. I think Gary Player said 'I've won two or three times with a fade, but I've won fifty times with a hook.' And I like the left heel to come up off the ground, like Nicklaus. I really studied Byron Nelson's swing. His divot looked like a dollar bill."

Penick does not ramble; he responds specifically to specific questions. "No, write them down in sequence," he tells his guest, who is jotting down the names of the best players Penick coached at UT. "Ed White, Morris Williams, Tommy, and Ben."

He is curious about his interviewer's golf background, which is extensive but undistinguished. "I've played enough to know how hard this game is," the guest says.

"No," says Penick, "you've played enough to know how easy the game can be."

He speaks for a time about his three most famous students. "I do get a kick out of the success of Kathy, Tom, and Ben.

"When I first taught Kathy Whitworth, she weighed 180 pounds. Her favorite sport was 'ice box.' She and her mother drove an old car down here from New Mexico.

"We cut off an old seven iron for Ben when he first started. 'Let's go hit a couple up to that green,' I said. 'Now let's go putt 'em in.' Ben said, 'Why didn't you let me know in the first place you wanted them in?'

"I think Ben's occasional wildness off the tee is caused by you [writers] writing about it. I do hate that all they talk about is his putter. When he's in trouble on the golf course, he can say 'ball, go through that opening.' He doesn't have to think about closing the club face or playing the ball back in his stance.

"No, I don't think Tommy practices too much; it's right for him to practice a lot, he's such a perfectionist. But his back is made out of something other than mine. Six months ago he came here and said 'Harvey, I'm hitting the ball too high.' He hit a ball, then another, and another. I couldn't tell the difference. He has got to analyze everything.

The conversation has obviously tired Penick. The visitor rises from the cart and shakes the old pro's hand. "You know, I've seen more golf shots than anyone who ever lived—too many of them were my own. I say that every time I give a talk. You can use it if you want."

Harvey Penick was the 1989 PGA Teacher of the Year. His best-selling *Little Red Book*, written with Bud Shrake, was published in 1992.

Judith Louise Torluemke Rankin

Born: St. Louis, MO
Residence: Midland

I thought I made a contribution. I was very successful while having a somewhat normal family life. I showed the other girls they could do it, too.

Ben Hogan met the Queen of England after he won the British Open in 1953. It made all the papers. Eight-year-old Judy Torluemke, a quiet, often lonely, only child, was impressed. Hogan met the Queen! Just from playing golf!

Paul Torluemke was quiet and lonely, too, for the same reason his daughter was. His wife, her mother, was dying. The malignant brain tumor, which had been diagnosed two years before, would finally kill Wuaneta Torluemke three years later. "Life was much more serious for me than for other little girls," Rankin recalls. Meanwhile, father and daughter played golf. It was a distraction.

"My father became somewhat obsessed with me having a nice life," says Rankin. "We had this fantasy that I would play in the British Women's Amateur—and win—then meet the Queen, just like Hogan did." It was not an idle dream. The two worked hard at it. "I was never much of a golfer," Paul Torluemke

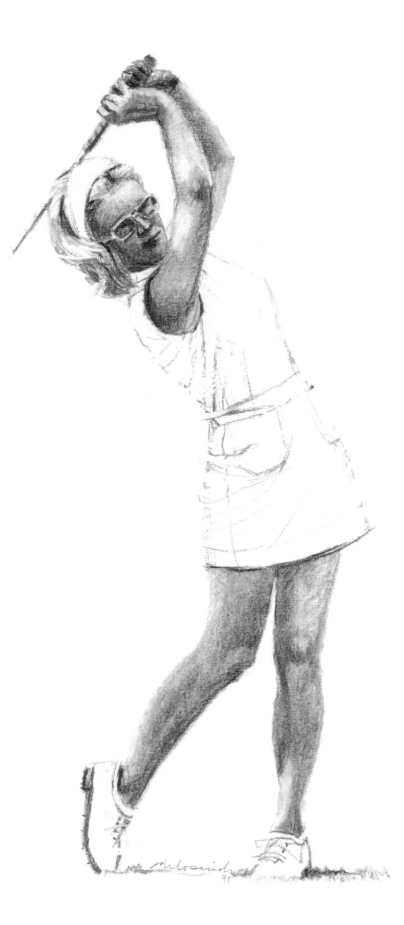

says. "We learned the game together. Trial and error. I didn't consider accepted methods [of teaching] to be written in stone."

The hours of practice and the homegrown instruction paid off. Rankin won the Missouri Amateur at age fourteen, the youngest ever to do so. She was the low amateur in the U.S. Women's Open the next year. That winter, the ninety-pound Rankin turned sixteen. The British Women's Amateur was coming up soon. The fairy tale was about to come true. Alone in her room, Rankin practiced her curtsy. "How do you do, Your Majesty?" she said to the mirror. And what should she wear to Buckingham Palace?

Team Torluemke left behind a warm spring day in St. Louis when their plane left for Europe. It was gray and sleeting when they arrived in Carnoustie, Scotland. The dream died. Rankin didn't play well, didn't win, didn't meet the Queen. And she didn't think she wanted to play golf anymore.

"When we got back, my father put his arm around me and said 'If you want to give this [golf] up, I'll understand one hundred percent,'" says Rankin. She thought giving up the frustrating game seemed like a good idea. A week later, Paul Torluemke was talking with Judy about a get-away-from-it-all fishing trip, when the phone rang. He answered.

"It's the St. Louis newspaper. *Sports Illustrated* wants to know your schedule. They want to put you on the cover." Judy got her clubs out of the closet. Her smiling face would appear on the magazine's cover that August, next to the caption THE BEST GIRL GOLFER.

The Best Girl Golfer of 1961 was a seventeen-year-old LPGA tour rookie in 1962. At the Tall City Open in Midland in 1967, she met a handsome cowboy named Yippy (Walter) Rankin. "Her brown eyes got me," says Yippy.

"He swept me off my spikes," says Judy. They settled in Midland and had a child, Tuey (Walter, Jr.), a year later. Here, at last, was a dream come true: "I'd always wanted a home and a family," Rankin says.

But golf still had a strong pull. So the Rankin family did something no one had done before. Mother, father, and baby piled into the Buick and headed out for the next event. Nannies and air travel were too expensive to consider back then. So while Judy

played professional golf tournaments, Yippy babysat and Tuey grew strong on hotel and golf-course food.

Rankin's golf game thrived. She was the best or the second best woman golfer of the 1970s. She was the first LPGA player to win one hundred thousand dollars in a year (1976); in 1976 and 1977, she won eleven tournaments. And she had the nuclear family she was denied as a child.

"My motive wasn't to contribute to women's lib," Rankin says. "I just thought it was healthy to do something you're good at and have a family, too."

Paul Torluemke and his daughter found happiness. "Judy's had about the best you can get out of golf," he says. "It's just the way I wanted it."

Judy Rankin won twenty-eight LPGA tournaments, three Vardon Trophies, and two Player of the Year awards. ABC Sports hired her as a television golf analyst in 1985. She was inducted into the Texas Golf Hall of Fame in 1987.

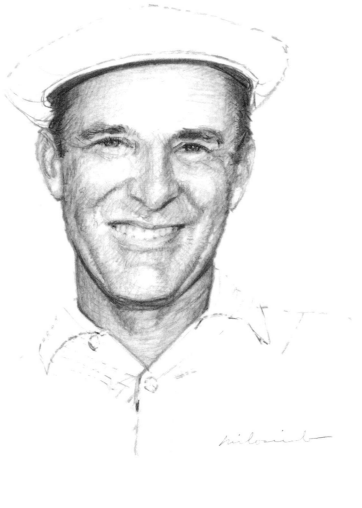

Henry Ransom

Born: Houston, 1911
Died: Bryan, 1987

He was proud of winning the World's Championship and being on the Ryder Cup team. But he was really most proud when they gave him a banquet at A&M, just three months before he passed away. He had very painful bone cancer, but even without taking any medication, he didn't feel any pain that day. Fay Ransom, Henry Ransom's widow

Henry Ransom had a beautiful swing. "If you were at a tournament, and you wanted to see a great golf swing—and if Sam Snead wasn't there—you'd go watch Ransom," Dave Marr says. And he got wonderful results with that classic stroke.

"I knew Henry when he was the pro at Hermann Park [in Houston]," recalls Charlie Crenshaw, Ben's father. "We played one day and he had sixteen birdies in thirty-six holes. Shot sixty-two and sixty-two. He was an ol' country boy. He believed in himself a lot."

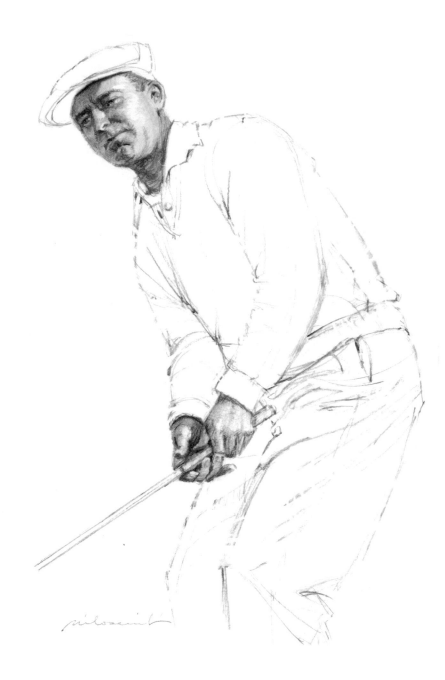

Ransom accomplished his sweet swing and low scores with the utmost dispatch. "He and [Gene] Sarazen were the fastest players of the era," says former Texas A&M golfer Johnny Henry of his old coach. "When his right foot hit [was lined up], he was gone." Ransom always insisted on playing Henry and another A&M golfer, Travis Bryan, for money. "But the bet was always for twenty-five cents, and he wouldn't accept a press. 'I play the same way for twenty-five cents or twenty-five hundred dollars,' he'd say," remembers Henry, adding, "I never beat him."

But why did Ransom play for trifling sums with college kids when he could have been on the tour competing for real money? The answer is simple, but hints at an underlying complexity: he preferred to stay at home.

"He *chose* to be a part-time player on the tour," says Frances Trimble, who conducted the last interview with Ransom before his death in December, 1987. "He was a lot better player than some others who got more publicity. I think he wondered what he might have accomplished if he'd played full-time. He was a tough old bird, extremely opinionated. He did things *his* way."

His "way," simply put by Travis Bryan, was "to go out there, win a little money and come home to his club job and ranch."

Farm, family, and hay fever were the ostensible factors that kept Ransom off the tour. The farm—ranch—was on 1,504 acres by the Navasota River in Hearne, near Bryan, bought with the twelve thousand dollars Ransom received for winning the 1950 World Championship. The family, headed by his wife, Fay, whom he met while he was the golf professional at Bryan Country Club, also exerted a powerful pull. And allergies, Ransom said, made it uncomfortable for him to play in certain locales during hay-fever season.

All of which makes Ransom's success on the tour—twelve wins in fifteen part-time seasons from 1945 to 1960—remarkable. And between tournaments Ransom sometimes went weeks without picking up a club. Fay Ransom explains that her late husband had "a clear mind and a glad heart, and the kind of confidence that let him relax between rounds or tournaments or seasons. He was very ambitious and diligent. Whatever he set out to do, he did."

Henry Ransom, a member of the 1951 Ryder Cup team, was the golf coach at Texas A&M from 1960 to 1975. Tour golfers Bobby Nichols and Frank Stranahan played for him. He was inducted into the Texas Golf Hall of Fame in 1981. Ransom was a dance instructor and a boxer (6-2 record) before becoming a golf professional in 1933.

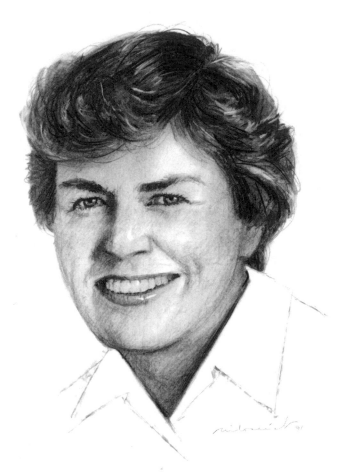

Elizabeth Earle Rawls

Born: Spartanburg, SC
Residence: West Chester, PA

Winning a tournament is exciting, but that's short lived. It's so satisfying to stand up at the end of our tournament and give $2.8 million to charity.

Betsy Rawls, a Phi Beta Kappa graduate in mathematics and physics at the University of Texas, became one of the top players in the history of women's golf. She was also the acknowledged master of the short game in the 1950s and 1960s: Kathy Whitworth likes to recall the time she saw Rawls get it up and down (a chip and one putt) from the side of a mountain in Spokane. Is there a connection, you want to know, between high academic achievement and success in golf? Can an understanding of physics help you chip and putt?

Rawls laughs off the suggestion. "No, I don't think so," she says. "The real benefit of studying and working hard [at UT] was that it trained me to concentrate. So I didn't have to learn how to think when I got out on tour."

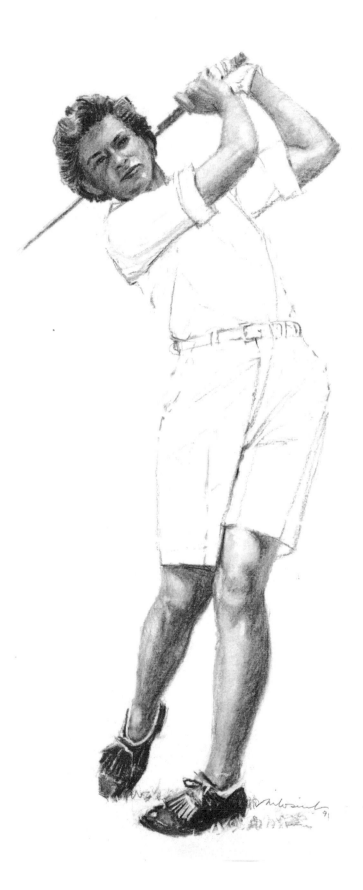

On the other hand, the cerebral Rawls admits that she has tended to "intellectualize" her stroke. "I've thought about my swing a lot, maybe too much," she says. Ironically, the woman with the game's best brain played some of her finest golf with her mind relatively blank. "I played best when I didn't think of mechanics. I could do that—just picture the shot I wanted—around the green. But I couldn't do it on full shots."

Rawls blames her inability to be completely instinctive on her "late start" in golf—age seventeen. The Rawls family moved from South Carolina to Arlington when Betsy was one. Her father, who had been a good amateur golfer, started playing again after a ten-year hiatus. An older brother wasn't interested, so her father asked Betsy to play. "I got hooked immediately. Golf's that kind of game," Rawls says.

Two years later, she played in her first tournament, the 1947 West Texas Invitational in Abilene. "I surprised myself by qualifying for the championship flight," says Rawls. "Then I got beat in my first match. Getting beat really inspired me." Within two more years, Rawls started a streak of winning at least one big event a year, amateur or pro, that lasted until 1966. In 1959, she won ten times.

The long win streak might not have happened—or might have taken a different form—if not for the Wilson Sporting Goods Company of Chicago. Rawls didn't consider joining the nascent LPGA tour when she graduated from UT. "Turning pro wasn't the thing to do back then—there wasn't enough money in it," she says. "Then Wilson approached me, and asked me to join their staff and give clinics and exhibitions between tournaments. They already had [Patty] Berg and [Babe] Zaharias. So I became an employee of Wilson. They paid expenses and a salary. *That* was a good job."

With Berg and Louise Suggs, Betsy Rawls dominated women's golf in the fifties. Like Jack Nicklaus, her first win on the tour was the biggest tournament, the U.S. Open. She won eight major championships, including four U.S. Women's Opens and two LPGA Championships, and forty-seven other titles of lesser note, like the Triangle Round Robin, Bill Brannin's Swing Parade, and the Opie Turner Open. The Opie Turner Open?

Rawls loves to remember the free-wheeling event staged by Waco Turner and his wife Opie for the men and women touring pros in Ardmore, Oklahoma. "They had tons of money," Rawls recalls. "There was a field in back of their house filled with Cadillacs. When the oil needed changing in one, they'd just buy another." The Turners paid bonus money for low rounds, birdies, eagles, and aces; Miss America distributed the cash during the daily post-golf party.

In 1975, the low-key, personable Rawls retired as a tour player to begin a six-year tenure as the LPGA's tournament director. After the final round of the McDonald's Classic in 1981, the founders of that tournament approached her as she was leaving for the airport. "We think it's time for you to settle down and run our tournament," they said.

Rawls, flattered, accepted. "It was the first time in twenty-five years that I *lived* anywhere," she says. So the new Executive Director of the McDonald's Classic bought her first furniture, dishes, pots, and pans and moved near the tournament site in Eastern Pennsylvania. She's happy. She is finally putting that degree in mathematics to work. "We get one hundred thousand fans a week, and we've given fourteen million dollars to charity, the most on tour. Two point eight million dollars this year," Rawls says. "I never dreamed it could be so successful."

Betsy Rawls won fifty-five LPGA events, including eight major championships. She is a member of the LPGA Hall of Fame and was a charter member and the first secretary of the women's tour. As an amateur in Texas, she won the Texas Women's Amateur twice, the Trans-National, and the Broadmoor Invitational. She won the Vare Trophy in 1959.

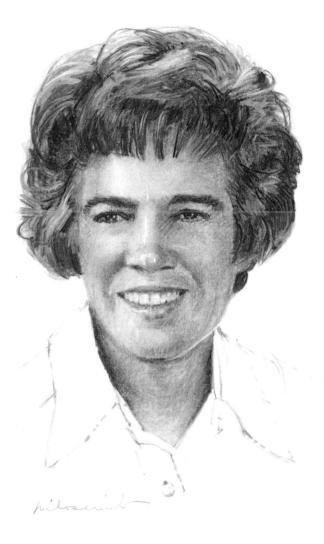

Polly Ann Riley

Born: San Antonio
Residence: Fort Worth

Probably I'm proudest of having been a captain of the Curtis Cup team [in 1962]. I was the first player to be named captain; it had been a political appointment. As my friends said, I took that very big.

With all the hubbub and bluster of the grand opening of a shopping mall, the Ladies Professional Golf Association staged its first tournament in January, 1950, in Tampa, Florida. See the best women golfers on earth! Patty Berg! Betty Jameson! Olympic heroine Babe Zaharias! Then Polly Riley, a five-foot-tall, twenty-four-year-old amateur hardly anyone had heard of, won the tournament. The LPGA was not amused. Polly who? An *amateur*? Due to the LPGA's pique, Riley's remarkable win has remained remarkably unpublicized. "I think I shocked them," she says.

Riley took up golf at age twelve. "The first ball I ever hit was off the first tee at Colonial," she remembers with a smile. "It was a Saturday morning 'playday'

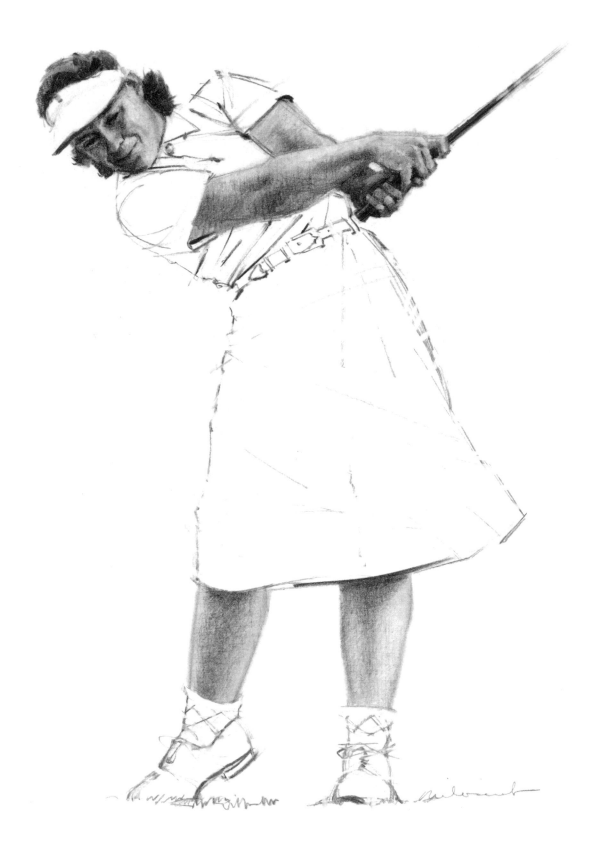

114

for the kids. In those days, most of the men worked on Saturday mornings, so the golf courses were dead. After a few holes, I was thoroughly hooked."

She and her two older brothers began riding their bikes each day to play at Ridglea, which was then a public course. They had a unique competition. "We'd pool our golf balls on the first tee, then split them up," Riley explains. "For instance, if we had fifteen balls, each of us got to start with five. We didn't keep score; whoever finished the round with the most balls was the winner.

"I rarely lost. My brothers were big on losing balls, and I was big on finding them."

Riley was soon competing successfully in national amateur events. Before going into semiretirement at age thirty-two—a new job didn't allow sufficient time off to play a full schedule—Riley had two unique accomplishments. She played on six Curtis Cup teams, the most individual appearances ever. And she had a winning record against the best player of the day, Babe Didrikson Zaharias.

"I don't mean this critically, but Babe had an intimidating presence. She knew it and used it to her advantage," says Riley, adding that the Babe was a great friend. "She scared the devil out of a lot of girls. I remember she said to one girl on the practice green before they played a match, 'I didn't know you putted with your finger down the shaft. Have you always done that?' That girl couldn't putt at all that day."

The first match between the diminutive, blonde Riley and the tall, strong Zaharias was a ten and nine Riley win in the finals of the 1948 Texas Women's Open. It was the worst defeat Zaharias ever had. In five head-to-head matches, Riley won three times. She was the only woman with a career advantage over the Babe.

"Babe knew that *I* knew what she was doing to get a psychological edge," says Riley. "After the first match, I believe *she* felt intimidated by *me*."

Polly Riley won the Southern Amateur six times, the Texas Womens's Open three times, the Western Amateur twice, and was runner-up in the U.S. Women's Open and Women's Amateur. She has been the public relations director for a restaurant chain for twenty-one years.

William Charles Rogers

Born: Waco
Residence: San Antonio

I was most excited by the birth of my children. Winning the British Open was my greatest achievement, but my happiest moment in golf was the first time I made the top sixty money winners. It was in the 1977 Kemper Open and I made a ten-footer to finish second. You would have thought I won the world.

Bill Rogers lost the 1981 British Open on the seventh hole of the final round. Then he won it back on the next hole.

Rogers had played superlative golf all week. He had built a five-shot lead going into the final round at Royal St. George's at Sandwich, England, on rounds of seventy-one, sixty-seven, and sixty-nine. The knee-high rough, narrow fairways obscured or hidden by huge sand hills, and wind at the 94-year-old course were mystifying to the rest of the field. Jack Nicklaus, for example, shot eighty in the second round. But Rogers, a skinny, competitive little guy from Texarkana, seemed to have cracked the code.

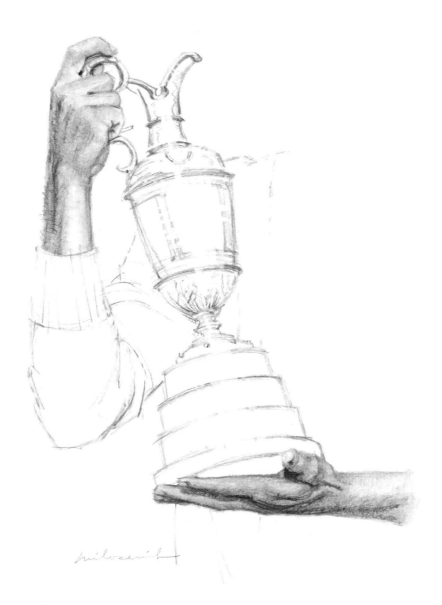

Rogers felt keyed up but in control as he made the long, scenic walk to the seventh tee. Above the waters of Pegwell Bay, the white cliffs of Dover were just visible through the overcast. They looked gray. But Rogers was indifferent to the view. Several players—Bernhard Langer of West Germany, Ray Floyd of the U.S., and Mark James of England—were making birdies. The lead was down to three.

"I thought it was inevitable that someone would make a run at me," Rogers recalls. "But one thing I was good at was not being too nervous before or during a round."

Rogers learned his coolness under fire from Jerry Robison, the golf professional at Northridge Country Club in Texarkana. Robison insisted that his promising thirteen-year-old pupil learn to gamble. "He started me playing in the men's groups. I had to play with my own money," says Rogers, smiling, nostalgic. "Many times I had to go to my father to get money to pay off my debts. Dad was good at subsidizing, but I wasn't too good at paying back. All this, the gambling, the needling from the men, thickened my skin."

The seventh hole at Royal St. George's is a relatively easy par five, a place to make up some ground or pad a lead. But Rogers hit two mediocre shots and found his ball lying, he recalls, "on an upslope, in a peculiar lie, about one hundred yards from the green." For reasons he can't remember, he hit an eight iron, too much club. He "chili-dipped" (hit behind) his chip from over the green, hit another poor chip, then missed the putt. Double bogey seven. The lead was down to one.

"Boy, I was on fire," Rogers says. "I'd let everyone back in the tournament. It was the perfect situation to panic." As he walked to the next hole, he tried to pull himself together. Come on, Bill. You've played so many good holes. Don't let one bad one ruin everything.

Rogers took a deep breath and walked onto the next tee. The bunker fronting the par three eighth— "the hardest or one of the hardest holes on the course"—is a huge wasteland of sand and scrub called Hades. Rogers swung a four iron and watched the ball hang in the air. The ball cleared Hades, but was still a hell of a long way from the hole, sixty-five

feet. Rogers negotiated the twenty-two yards in two putts; his confidence and composure coalesced.

"I was talking to Seve [Ballesteros, the Spanish golf champion] a month later," says Rogers. "Seve said 'De mas important thing you do is two-putt number eight.' I agreed."

Rogers's final round seventy-one was good for a four-shot victory and a place in golf history.

Bill Rogers has won, in addition to the 1981 British Open, five PGA tour events. In 1973, he was a member of the Walker Cup team, captain of the University of Houston golf team, and a first-team All-American. In 1972, he was a second-team All-American for the University of Houston golf team, and All-American Intercollegian champion.

Marilynn Louise Smith

Born: Topeka, KS
Residence: Richardson

I'm proudest of the friends I've made.

The screen door creaked open and banged shut. "How did you do today, honey?" called Alma Smith over her shoulder. She was standing at the sink, peeling potatoes. Her daughter Marilynn, a nine-year-old tomboy with a red face, torn blue jeans, and a baseball glove, shuffled into the kitchen. Marilynn was mad. Her team lost. She slung her glove to the floor. "Aw, sh——," she said, with feeling.

That evening Marilynn sat glumly in the living room, wondering if the taste of Lifebuoy soap would ever leave her mouth. She heard her parents conferring quietly in the kitchen. Now Dad's gonna get me, too, she thought. Here it comes. "Marilynn," said Lynn Smith, "your mother and I have decided you need to get into a more ladylike sport. Why don't you come down to the country club with me tomorrow?"

To her parents' delight, certain coarse words disappeared from Marilynn's vocabulary as golf replaced

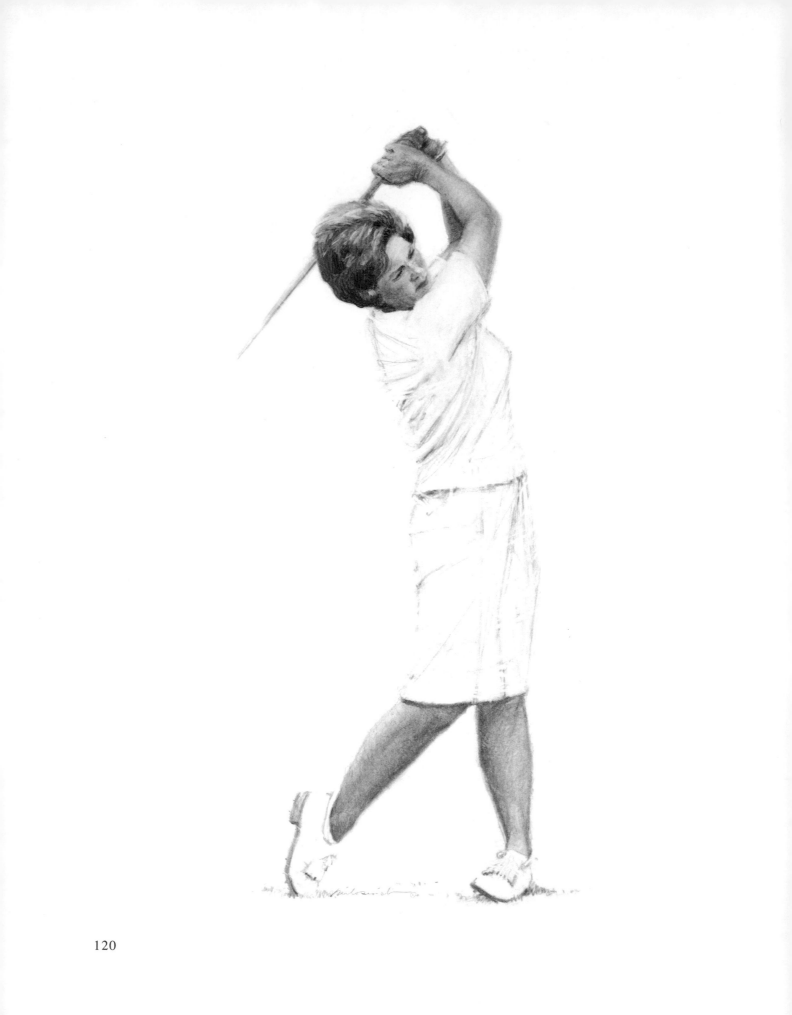

baseball. And she turned out to be a marvelous player. Within eight years of the "aw, sh——" incident, Smith won the first of her three consecutive Kansas State Amateurs. At age twenty, she won the National Collegiate Championship for the University of Kansas, then dropped out of school to turn pro. Yet she missed her old sport. "Baseball was my passion," says Smith. "I still like it as much as golf."

The modern Ladies Professional Golf Association (LPGA) was founded in 1950, the same year golf equipment manufacturer Spalding signed the effervescent Smith to the first of twenty-seven one-year contracts. Smith—along with Babe Zaharias, Patty Berg, Betty Jameson, and nine others—was a founding member of the new organization.

Tournaments on the LPGA tour back then were most often Chamber of Commerce affairs. Among Smith's twenty-two victories were such monuments to boosterism as the Heart of America Open (Kansas City), the Mile High Open (Denver), the Sunshine Open (Miami), and the Cavern City Open (Carlsbad, New Mexico). Prize money was low; Smith received just seven hundred dollars for winning her first tournament, the Fort Wayne Open. Travel was by car, caravan-style ("so we could help each other with flat tires"). It was an exhausting life. In 1952, for example, the tour went from Georgia to California to Chicago to Philadelphia in consecutive weeks.

The golf courses were tough, too. "We played the men's tees back then. Some of our courses were 6,900 yards long," recalls Smith. "The Babe [Zaharias] wanted it that way. So the rest of us started swinging harder."

When the tour would come to a new town, Smith, a one-woman public-relations department, would head for the local newspaper office. She'd tell the sportswriters her Lifebuoy soap story, or the latest about Olympic heroine-turned-golf-pro Zaharias, or about the time her father asked University of Kansas Athletic Director Phog Allen for some expense money so Marilynn could play in the women's national collegiate golf championship. Said Allen: "Sorry, Mr. Smith, we have no money for that. It's just too bad your daughter's not a boy."

Of Marilynn Smith's twenty-two LPGA wins, two are major titles, the 1963 and 1964 Titleholders. "My biggest thrill in golf was beating Mickey Wright for the '63 Titleholders," she says. Smith founded and organized the Marilynn Smith Founders Classic in 1987.

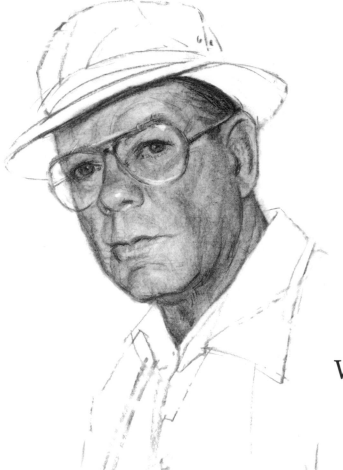

Wilburn Artist Stackhouse

Born: Atoka, 1910
Died: San Antonio, 1973

I think my father was proudest of starting the youth golf program in Seguin . . . and of the ten years he was in AA. Wayne Stackhouse, Lefty's son.

Golf's myths and legends are nourished and preserved primarily by two groups, golf writers and barroom storytellers (some people, of course, are members of both organizations). Writers and imbibing oral historians love to tell tales about people like Hogan and Nelson because they were such great players, and about characters like Titanic Thompson and "Lefty" Stackhouse because they were so colorful.

Truth is often the first casualty in these yarns. For instance, one story making the rounds had it that such was the dedication of Byron Nelson that immediately after accepting the trophy for winning the 1939 U.S. Open, he excused himself to go down to the practice tee to work on his swing. "No, that would be ridiculous," said Nelson. "A bunch of people from Reading [Pennsylvania, where Nelson was the golf pro] were waiting for me, and we left right away.

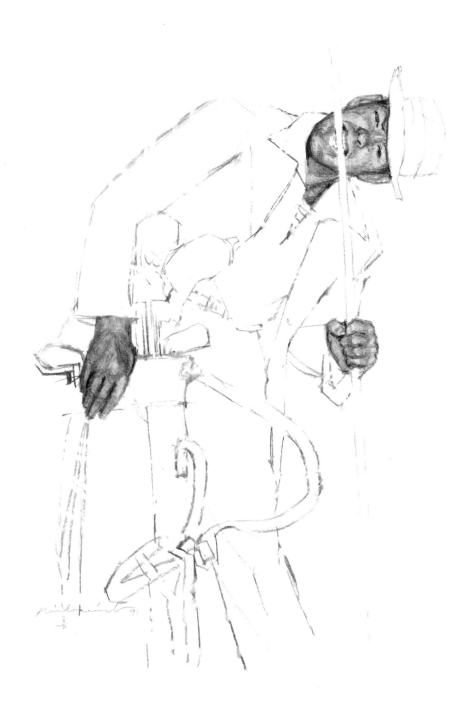

After my game got going well, I didn't practice too much. It bored me."

So with considerable skepticism you meet Wayne Stackhouse, son of Lefty. You are prepared to debunk more myths. Those stories about your late father—they were mostly hogwash, right?

"No," he says, "they were mostly true."

Here, then, are samples of the legend, true or not, in part told by the writers who found Lefty Stackhouse irresistible:

"Lefty admits that two things ruined him on the pro tour: alcohol and temper. 'If I played a good round, I would celebrate,' Lefty says. 'My idols were Walter Hagen and Tommy Armour. They always had a bottle of scotch sitting in front of them, and I wanted to be like them. If I had a good round, there was no way to miss that scotch bottle.'" John Thames, *Fairway Facts* (newspaper column) 7/22/69.

"Stackhouse is a small, rawboned, leathery faced man with whipcord muscles and a hairtrigger temper . . . Ben Hogan remembers that after duck hooking a drive, Stackhouse walked over to a thorny rose bush and began whipping his right hand back and forth, with the thorns tearing gashes. 'That will teach you to roll on me.'

"Then he looked at his left hand. 'And don't think you're going to get away with it either,' he said, and whipped it back and forth until it too was ripped and bleeding.'" *Atlanta Journal*, author and date unknown.

"Lefty was leading a tournament in the second round when "his ball came to rest in a palm tree. He took 3 or 4 swipes at it, jumping up like a midget trying to swat a fly on the ceiling.

"He flipped the club to his caddy with the remark that he would see him back at the club house.

"Without a word to his playing partners, Stackhouse headed in that direction in a straight line. When a water hazard loomed in his path, Lefty didn't change direction. He walked in one side of the hazard, disapppeared momentarily, then came walking out the other, sopping wet." Dick Peebles, *Houston Chronicle* 12/10/73.

"Lefty carried on a constant chatter on the golf course, threatening his clubs, his golf balls and himself if any of these things did not respond to a certain shot. He was prepared to carry out these threats and he did—even against himself.

"Lefty flubbed a gimme on No. 18. He stood up, roared and ran straight off the green for a tree, which he butted severely with his head. It is not clear which vehicle suffered the most damage." Bob St. John, *Dallas Morning News*, 1969.

After a posttournament locker room celebration with Ky Laffoon, Stackhouse had to be helped back to his hotel room. "Awakening nine hours later, I noticed that I still had on my cap, my shoes, and my clothes. Besides that, all I knew was that I felt terrible. So, I grabbed the phone and told the Bell Boy to rush me two beers before I died." Lefty Stackhouse, from an untitled reminisence.

"In his prime—and he was primed often—W.A. 'Lefty' Stackhouse was perhaps the most colorful man golf has ever had . . . The legend will live long. But it will never be embellished as many legends are.

"Lefty taught me to play golf and, more importantly, to *love* golf. In ninety-nine degree heat, off bare lies, with, I assume, monstrous hangovers, he tried valiantly to impart knowledge of the swing. He never lost patience with me . . . never hollered. Besides, 'Dutch,' Lefty's wife, made the best cheese sandwiches in Laredo." Frances Trimble, ActingDirector, Texas Golf Hall of Fame, 1992.

"Stackhouse didn't leave any room for exaggeration." Gene Gregston, *Fort Worth Star Telegram*, 1958.

Following his career on the tour in the 1930s and 1940s, Stackhouse was the pro at Starcke Park Municipal golf course in Seguin. He helped coached Seguin High to five consecutive state high-school golf championships and was the South Texas PGA Pro of the Year in 1965.

Earl Richard Stewart, Jr.

Born: Dallas, 1921
Died: Quitman, 1990

I never heard him say, but I think he would have been proudest of his national championship women's team and winning the Dallas Open.
Chip Stewart, Earl Stewart's son

The two hundred people in the chapel alternately look at each other, then at nothing, the way people do at funerals. An unseen organist completes a second dolorous rendition of "Rock of Ages," and the Reverend Carl Anderson emerges from behind curtains to begin the service.

"On behalf of Dorothy, Chip, and Mark, and their families, thank you for honoring Earl today," Anderson says. He reads selections from the Old and New Testaments, then talks about the deceased's career, his love of family, and "the other passion in his life: golf." Personal remembrances of Earl Stewart, Anderson says, will now be presented by three friends.

Jay McClure speaks first. McClure is a golf professional and the former women's coach at Texas Tech University. A gray-haired, bearded man with a sun-

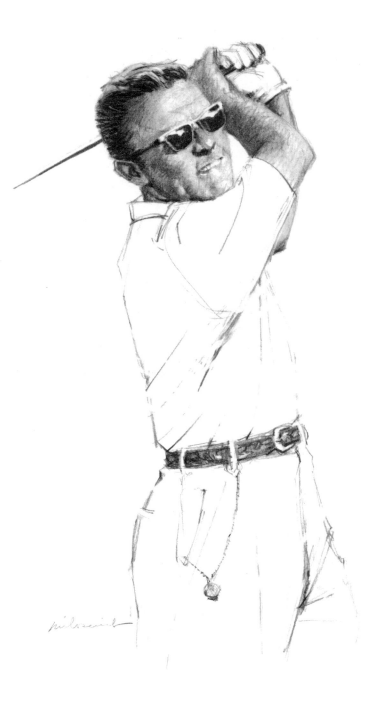

burned face, he is composed and articulate. "I remember the first time I saw Earl Stewart," he says. "It was at a golf tournament in West Texas. He was this little skinny guy, wearing very baggy pants—what we used to call a 'zoot suit'—and he had a watch chain that hung down to his knees. He hit the ball with pants, chain, everything. He was the best amateur golfer in the world at his peak.

"Not many people know this, but out of the genius of Earl Stewart's mind came the idea for the 'tour school,' the qualification tournament the PGA uses today. Earl proposed the idea in 1967, and it was adopted in 1968. As I recall, the current commissioner, Deane Beman, won the U.S. Amateur that year and decided he wanted to play the tour. He didn't like having to qualify. 'I'm the Amateur champion. I belong on the tour,' he said. Earl said 'prove it.'

"I really believe Earl found his niche in life as golf coach at SMU. He could be a little bit hard-headed [there are knowing chuckles throughout the chapel at this observation], but he taught those kids his philosophy: be honest, play within the rules, and always give one hundred percent. He was a champion in everything he did—as a player, as a coach and as a man."

Randall Meeks, a tall, bespectacled gentleman in his forties, follows McClure. "I was Earl Stewart's caddy in the Dallas Open at Oak Cliff Country Club in 1961," he says. The Dallas Open in those days was a regular PGA Tour event, like the Colonial and Byron Nelson tournaments are today. Stewart, the host professional, won the tournament. No host pro had ever done that before. And no home pro has won on his own course since.

Meeks's parents were members at Oak Cliff. "When the Dallas Open came to our course, Earl used his influence to let us junior golfers caddy in the tournament," recalls Meeks. "We got to pick who we wanted, too. All the best players were there: [Ben] Hogan, [Arnold] Palmer, [Ken] Venturi. I went up to Earl and said 'Mr. Stewart, I'd like to caddy for you.' He said 'That would be fine, Randall.' He treated me like I believe you're supposed to treat people. He never talked down to me.

"I asked to caddy for Earl because I figured he knew the course so well, he'd never ask me for a yardage or to read a putt. And I knew I wouldn't have to shag practice balls the way the other kids did, because Earl just didn't have time to practice during the tournament. He was always making sure the other players got their mail or that their hotels were all right. Then he *won*."

Kyle O'Brien, an athletic-looking young woman, rises from her seat in a front pew and walks to the podium, past the body of her old coach. O'Brien was tournament medalist on Stewart's 1979 NCAA champion team; she succeeded Stewart as SMU women's golf coach in 1987.

"Earl Stewart produced seven All-Americans, two national champions, and sixteen tour players, including nine on the LPGA tour," says O'Brien. Then, with emotion: "He taught us never to give up on ourselves and never to accept less than our best effort. He always said the right thing. Coach Stewart had such a positive effect on women's golf, locally and nationally.

"He's gone now. But he will never leave us."

Earl Stewart of Sunset High in Dallas was the state high-school champion in 1937 and 1938 and won the NCAA championship while at Louisiana State University in 1941. He won three PGA tour events, though he played on the tour only three years. Stewart won the Texas PGA as an amateur and as a professional. He coached at SMU from 1975 to 1987 and was elected to the Texas Golf and NCAA Golf Coaches Halls of Fame.

Alvin Clarence Thomas
a.k.a. Titanic Thompson

Born: Rogers, AR, 1892
Died: Fort Worth, 1974

Ti was probably proudest of his ability to set guys up . . . Pullin' off the scam was what really got his motor runnin'. Carlton Stowers, Titanic Thompson's biographer

One important reason for the incredible success of Titanic Thompson, one of the greatest gamblers of all time, was simple. He cheated.

A magnificent disregard for fair play wasn't his only advantage, of course. He also had imagination, wonderful hand-eye coordination, impenetrable confidence, a willingness to practice, and an easy-going "trust me" personality. And Thompson was a great actor. As needed, he would appear to be either guileless or vulnerably overconfident when proposing a wager—on a game of pool, poker, dice, golf, what have you. But the bet was usually rigged; Thompson was a liar.

"He should have been killed a long time ago," says one old golf professional who knew him well. "He was a desperado. He died owing me money, a lot of money. I'm not proud of my association with him.

"He was real soft speaking, spoke real careful. He liked to flash his money and he liked to carry all he had. They tried to get him for that Rothstein thing, but he got out of it."

Arnold Rothstein was the high-profile New York City gambler who allegedly "fixed" the 1919 baseball World Series. "That Rothstein thing" was his murder, in which Thompson was implicated but was not convicted. Thompson may not have murdered Rothstein, but he did cause the demise of a man named Johnson in 1910, with a hammer. He killed four men in two separate incidents in Missouri in 1917, with his .45-caliber revolver, and another man in Tyler in 1932, with the same weapon. He served no jail time for these killings. Self defense.

Despite all this, Thompson has always been a romantic figure. Who did he lie to and cheat, after all? Just other gamblers who should have known better. If he had to kill other armed men to defend himself, well, that's okay, too; survival was the first rule in the sometimes violent society of gamblers. And well before his death, Thompson's skill with a golf club—and his success at finding and fleecing willing bettors for big money—was legendary.

"Hell, I could beat you left-handed," Thompson would say, goading some unfortunate and increasingly unhappy golfer as he collected his winnings after a match. "Double or nothing? You got it." Thompson was, you guessed it, ambidextrous, and played exceptionally well on either side of the ball. "Don't look like there's much competition around here," he would observe to his potential opponents at another golf course. "Hell, I believe I could beat you two with a caddy as my partner. How about you, son? You play golf?" A young man in bib overalls standing in the caddy yard would take the piece of straw out of his mouth with a "Who, me?" gesture and say that yes, he did play a little, and would be glad to complete the foursome. "Damn good player for a caddy," the victims would mutter as they paid Thompson afterward. The "caddy" would be an in-cahoots professional golfer; Thompson lived to gamble, but he didn't like to take chances.

Author Carlton Stowers, in his book *The Unsinkable Titanic Thompson* (Eakin Press, 1982; Paper-Jacks, 1988) tells this Ti tale, which takes place in midwinter in Chicago in the 1930s: "Hanging around one of the municipal course clubhouses, he again used his annoying braggart routine to work up a bet. 'I may not be one of your top ten golfers of all times,' he told his audience, 'but I reckon I'm probably the world champion off the tee box. Hell, I never hit one under 300 yards and there are days when I'm feeling really good and can get it out to over 400. I bet I can drive one 500 yards if I was ever forced into a position of having to.'"

Several large bets were made and Thompson led his flock out onto the frigid golf course. "Then, to the dismay of those who stood watching him, he positioned himself at a right angle to the fairway, facing the huge ice-covered lake that bordered the course. Without so much as a practice swing, he swung into the ball and watched as it gained altitude, then began descending as loud curses began erupting from his gallery.

"'If one of you boys wants to step it off, feel free,' smiled Thompson. 'But I suspect that drive is gonna wind up measuring somewhere close to a mile before that ol' ball decides to stop.'"

Titanic Thompson once beat Byron Nelson sixty-three to sixty-four in a match for one thousand dollars at Ridglea Country Club in Fort Worth.

Lee Buck Trevino

Born: Dallas
Residence: Austin

What am I proudest of? Beating Jack Nicklaus in that '71 play-off for the Open, no doubt.

Happy-go-lucky Lee B. Trevino was feeling neither happy nor lucky early in 1971. His mother, Juanita, was dying; she would be dead from cancer that fall. His marriage was crumbling, as was his relationship with his business partners from El Paso. He started to drink too much and sleep too little. "For the first time, Lee was callous and aloof to me," recalls his agent, Bucky Woy. "I didn't hold it against him. I knew there was a lot of trauma in his life." And though the two had been as close as brothers, Trevino and Woy soon parted company, to their eventual regret.

In March, in the locker room at Doral Country Club near Miami, Jack Nicklaus paused to have a word with Trevino. As writer Robert Sommers quotes Nicklaus to Trevino: "I hope you go right on clowning and never learn how good you are, because if you do, the rest of us might have to pack up and go home."

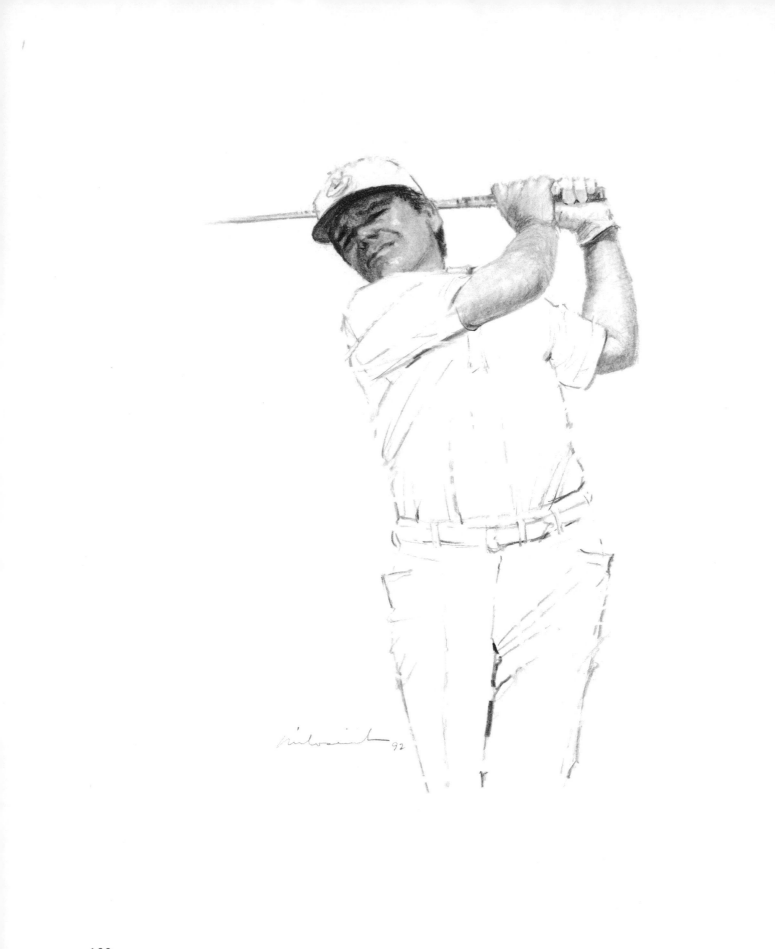

132

Trevino was touched that Nicklaus, the golfer he respects above all others, cared. He vowed to do better. It was a turning point.

Trevino's renaissance became apparent the next month, when he won the Tallahassee Open. In May, he won at Memphis. He stopped in Dallas after the Memphis tournament to visit his old friend, Dennis Lavender, the pro at Cedar Crest. "I'm gonna give you a putter for those U.S. Open greens," said Lavender.

Trevino hefted the second-hand Wilson Arnold Palmer model club. "Thanks," he said, "I'll use it."

In June, at the Open at Merion, near Philadelphia, Trevino and his new putter shot seventy, seventy-two, sixty-nine, and sixty-nine for a total of 280. Good enough to win—or was it? One other player, by lipping out a birdie putt on the final hole, also shot even par 280. There would be a play-off. Trevino's opponent would be his hero/nemesis, Jack Nicklaus.

Nicklaus is blond, fair-skinned, and concentrates so hard on his golf that spectators can feel like intruders at a church service. Trevino is dark complected, dark haired and positively *needs* to talk and laugh during a round. "I *know* I can play. I'm not worried about the next shot or any shot," he says, "so my concentration is fifteen seconds a shot. After that, we can talk about football." This would be a play-off between opposites.

On the first tee, a laughing Trevino held up a rubber snake he kept in his golf bag. The gallery laughed too, feeling the same release from the drama and tension of the moment that Trevino did. Nicklaus sat quietly at the back of the tee on a spectator's chair while his mugging opponent dangled the toy reptile at the end of a club. Nicklaus joined in the merriment—he asked to see the fake snake, then flung it back to Trevino—but his smile seemed forced.

Trevino started faster than Nicklaus and led by two shots after ten holes. As Sommers writes, "Nicklaus didn't give up . . . but Trevino wouldn't crack. When Nicklaus birdied the eleventh, Trevino birdied the twelfth . . . Through it all, Lee seemed to keep smiling while Jack's expression grew more drawn."

Trevino won the play-off, sixty-eight to seventy-one, for his second U.S. Open title. Three weeks later he won the Canadian Open and the week after that, the British Open. No one else has ever held these three national titles simultaneously. Trevino was happy-go-lucky again.

Lee Trevino has more than forty professional tournament wins to his credit. He has been on six Ryder Cup teams and captained a seventh. He won the Vardon Trophy five times, the British Open twice, the PGA Championship twice, and the U.S. Open twice. Trevino, the 1971 Player of the Year, is a member of the PGA and World Golf Halls of Fame.

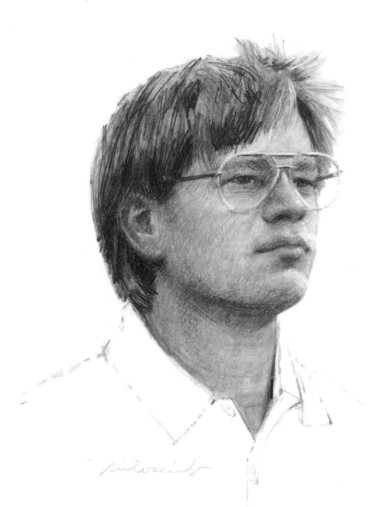

Scott Rachal Verplank

Born: Dallas
Residence: Edmond, OK

I haven't really felt too proud of myself.

Scott Verplank is explaining himself.

"I've got no chance to play well if I keep tearing myself down," he says. "I never give myself credit. I'm too critical. I need to lighten up." Verplank is only twenty-six, he has won two PGA Tour events; he's just shot sixty-eight at Colonial, one of the tour's toughest golf courses; and he's telling you what's been wrong?

Verplank owes no explanations or excuses. Each of his perceived failures has been matched with brilliant success. He was the best amateur golfer since Jack Nicklaus or Ben Crenshaw, in part because he did something Big Jack and Gentle Ben never accomplished, a feat no one had pulled off since Doug Sanders won the Canadian Open in 1954. Scott Verplank, amateur, won an official tour event, the 1985 Western Open. Runner-up Jim Thorpe got the seventy-five thousand dollar first prize. Verplank got the trophy, hearty congratulations from all present—and

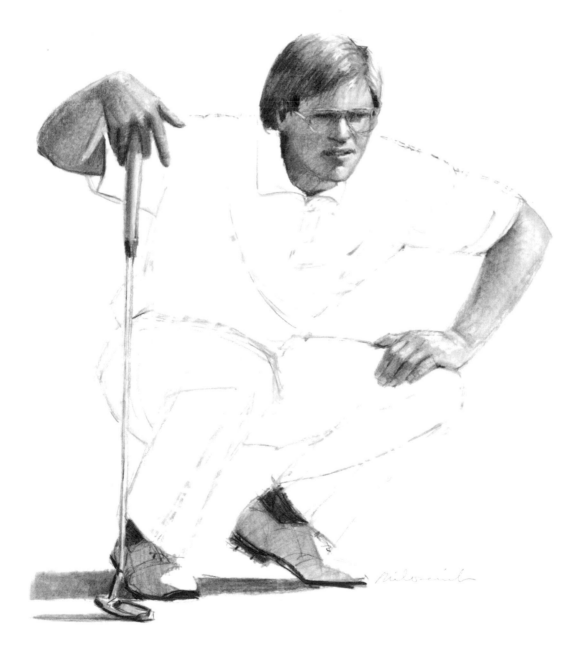

the burden of being anointed professional golf's next superstar, before he had ever won a dime.

"I had tremendous focus then," Verplank says. "I just wanted to see how good I could be. I allowed myself to play with confidence. I won four of the five amateur tournaments I played that summer.

"Nervous? No. I was ahead going into the last round [of the Western Open], and I feel great with a lead. I said to myself 'Why the hell wouldn't I win now that I have the lead?'"

Every golfer—perhaps, every athlete—has periods of bullet-proof confidence followed by intervals of paralyzing self-doubt. For the enormously talented, introspective Verplank, the cycle has been especially vivid. He turned pro in 1986 and the golf world held it's breath. But Golf's Next Superstar won only nineteen thousand dollars all year, tip money. Verplank wasn't much better in 1987; the golf world exhaled in disappointment.

Then the wheel turned in 1988. Verplank won $366,000 and his second tournament. But he finds it hard to accept success. "I *should* be proud of winning the Western at age twenty-one and the Buick Open at twenty-four," he says. "But I haven't ever really felt too proud of myself."

In addition to his two wins on the PGA tour, Scott Verplank won the United States Amateur in 1984, the NCAA championship in 1986 and eleven other important amateur tournaments. He has been plagued by injuries, his pro career yo-yoing down in '89 ($82,000 won), up in '90 ($303,000), and down again in '91 ($3,195).

Kathrynne Ann Whitworth

Born: Monahans
Residence: Trophy Club

I'm tickled about the winning, but that was the end product of something I enjoyed doing. I'll probably look back on my involvement with the LPGA with the most personal satisfaction.

Imagine for a minute you are in the back seat of a green 1953 Plymouth. The year is 1957, the month is June. It's hot. The car has no air conditioning and no radio. Better loosen your collar; you have a 450-mile trip in front of you, from Jal, New Mexico, to Austin, Texas.

In the front seat are Dama (pronounced dame-ah) Whitworth, a tall, slim woman (the driver and owner of the rather spartan vehicle), and her eighteen-year-old daughter, Kathy, also tall, but not slim. *That's Kathy Whitworth?* The pre-1960 Kathy Whitworth was a big girl, over two hundred pounds at her peak.

Isn't West Texas ugly? you observe. And why are we going to Austin? Kathy turns in her seat to face you. She has a big smile and a strong chin, like her mother. "Hardy Loudermilk, my pro at Jal Country

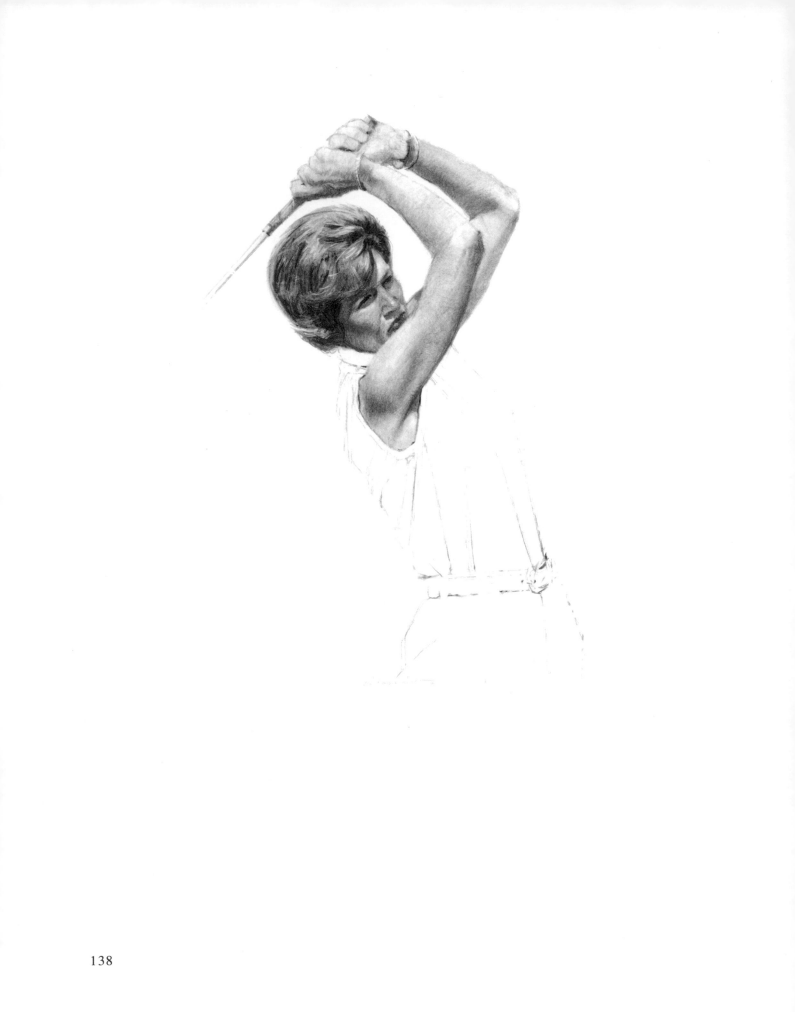

138

Club, set it up. Hardy has this big Indian face and a great personality. Last week, he asked me, 'Do you want to turn pro?' 'Yes,' I said. Hardy said 'I don't know enough. Let me get you a better teacher.'

"That's why we're going to Austin. Harvey Penick is going to give me lessons."

The Whitworths were to make the pilgrimage to Austin Country Club and Mr. Penick several more times that year. It was not a vacation: for three or four days at a time, Kathy would hit balls from sunup to sundown; Penick remembers Dama, with notepad and pencil, leaning forward in a lawnchair, taking down everything he said during his lesson with Kathy.

"I was scared and so was my Mom," says Whitworth. "I still get nervous when I see Harvey. You just feel so bad about taking up his time, he's so busy. But, you know, I don't remember him charging us after that first lesson."

Harvey would call Hardy to discuss what he'd worked on with Kathy each day, "so Hardy could make me practice the same things back in Jal." Whitworth became a disciple of Penick's nondoctrinaire, laissez-faire approach to golf. She gets worked up on the subject: "Teachers today don't give you an option," Whitworth says. "They've all got video cameras. But Nicklaus and Lopez would never have been great players if their instructors had used video—'See, Jack, you shouldn't lift your right elbow like that.' We all have faults in our swings—everyone except Mickey [Wright]. I've never seen myself swing and I don't want to.

"Harvey used to say he could put a hat on my head—but it wouldn't be *my* hat until I'd pulled on the brim a little or tilted it the way I like. Same thing with the golf swing—there are no absolutes."

So Whitworth, her game untouched by small thinking or orthodoxy—she retained a small loop in an otherwise classic swing—became an LPGA rookie in 1959. Mom still drove. She lost her *avoir-dupois* that first year on tour and became the willowy Whitworth that golf fans are familiar with. As she lost weight, she gained a mentor: LPGA founder and Hall of Fame player Patty Berg. Berg secured a sponsorship for the incredible, shrinking rookie with

Wilson (the giant golf/sporting goods company), who supplied equipment and financial help; in return, Whitworth was required to give golf clinics. "I had to go down to Florida for six weeks so Patty could teach me how to give a clinic. It was scary as the devil at the beginning. I had no polish at all and made all kinds of mistakes," says Whitworth, smiling at memories of thirtysomething years ago. "But I learned so much from Patty. It was great training, really instrumental in my success."

Now, Whitworth had it all: the support of her family; excellent fundamental teaching from Loudermilk and Penick; help in the finer points from Berg. In 1962, she began to win golf tournaments. She didn't stop winning until 1985, eighty-eight victories later. Which makes her the winningest golf professional, man or woman (Sam Snead won eighty-four times) in history. Which gives special relevance to the chapter "How to Win" in her instruction book *Golf For Women*. Here, then, are a few excerpts:

"One key to my game over the years is that I have never really cared how a shot looks, whether people think I played a hole correctly.

"You don't ever think about winning. You don't think about losing. You think about how you are going to best get this ball into the hole.

"This is what it takes to win: a fairly good, or effective golf swing, composure, and concentration.

"I cannot stress this too strongly . . . if you're constantly thinking about your golf swing . . . you are not thinking about the right thing, which is 'Where do I need to hit the ball?'"

Kathy Whitworth was the LPGA's leading money winner eight times, its Player of the Year seven times, and winner of the Vare Trophy seven times. Six of her record eighty-eight professional victories were in major championships; she won six other "unofficial" events. She is a member of the New Mexico, Texas Sports, Texas Golf, World Golf, and Women's Sports Foundation Halls of Fame.

David Glenwood Williams

Born: Randolph
Residence: Wharton

I'm proudest of the accomplishments of my players when they got out of school.

The brown paneling in Dave Wiliams's den is barely visible. Every wall is covered with plaques, mementos, and photographs of his championship teams. Williams, one of the most successful college coaches in history, won sixteen national championships and 400 or so other tournaments as golf coach at the University of Houston. That's a lot of plaques.

Williams conducts a tour around the museum-like room. Here is a framed testimonial. Over here is a picture of the first national championship team, in 1956—"You know we only had four players? [college golf teams usually have six players, low four scores count] That's Rex Baxter, Richard Parvino, me, Jim Hiskey, and Frank Wharton. You know Frank? We love Frank Wharton." There's the 1985 team, the last Williams-coached team to win the National Collegiate Athletic Association: "That's Elkie [Steve Elkington], Billy Ray [Brown], Mike Stanley." Williams

pauses at a plaque given to him by his 1977 team, inscribed to "the world's winningest coach." He murmurs, *sotto voce*, "God, I miss coaching. My health wouldn't have gone bad if I was still coaching."

It's a shame that physical problems—diabetes, among them—and age—mid-seventies—forced the highly strung Williams into retirement; college golf misses him as much as he misses it. For the dynasty he built at Houston, like the one John Wooden constructed in basketball at UCLA, gave the sport what it lacks today: a king. From the mid-1950s to the mid-1980s, the rules of the road in college golf were simple. Can you, high school golfer, play for the best? Then you must go to Houston. Can you, college golfer, beat the best? Then you must beat Houston.

How did he do it?

"Dave Williams was a great psychologist," says Wharton, one of five Houston Cougars to play on three national championship teams. "He pumped you up. Told you you were great. 'You're my main man,' he'd say. He always kept us upbeat—and he kept me in school.

"I didn't realize until the last few years how good he was and how much he did for us."

Harry Fouke, the Houston athletic director from 1945 to 1979, remembered another Williams characteristic—enthusiasm bordering on zeal—as a reason for his success. "At one time," said Fouke in 1981, "Dave thought golf was the single most important sport in the United States, a little ahead of football, and he was was trying to out-recruit the football team." As the national championships accumulated, recruiting became routine. Good players flocked to UH. The freshman team alone often had "twenty-five very good players" recalls John Grace, runner-up in the 1974 U.S. Amateur, a Cougar golfer from 1966-1970. "The competition was tremendous just to qualify to make the team for the next tournament." Williams, like the old lady who lived in a shoe, had so many good players that he often entered two Houston teams in some events. Sometimes, the "B" team won.

"The biggest thing a coach has to do is motivate the kids to be good players, go to school and have good morals," says Williams. "I think luck had a lot to do with our good record."

Jack Burke, Jr., has another explanation. According to the owner of Champions Golf Club, "Dave Williams was the greatest promoter since the Ringling Brothers. That's why he was so successful." Williams promoted the UH golf program by having his players participate in local charity golf tournaments, including one Williams himself organized, benefitting cystic fibrosis research. The Cougars played in club tournaments, too. "Each one of us played with three ladies in annual tournaments at River Oaks, Houston Golf Club, and Champions," recalls Grace. "It was a combination fund-raiser for the team and a thank you to the clubs for letting us play their golf courses."

Wiliams asks his guest if he would like to have dinner or to spend the night. Lots of his trophies and awards are in boxes, you understand; the walls can't hold them all. There is still a lot to see.

Dave Williams's teams won five straight NCAA championships in 1956-1960 and won twenty-one consecutive tournaments in 1957-1960. He is a member of the NCAA Golf Coaches Hall of Fame. Some of the tour professionals his program produced: Rex Baxter, Phil Rodgers, Jacky Cupit, Richard Crawford, Homero Blancas, Kermit Zarley, Marty Fleckman, John Mahaffey, Bruce Lietzke, Bill Rogers, Keith Fergus, Ed Fiori, and David Ishii.

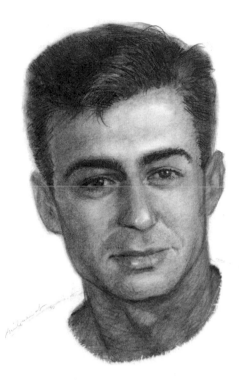

Morris Williams, Jr.

Born: Austin, 1931
Died: Eglin Air Force Base, FL, 1954

 Morris Williams, Jr., should have been the next great player from Texas. He was the likely successor to Byron Nelson, Lloyd Mangrum, Jimmy Demaret, and Ben Hogan, all of whom won on the tour for the final time in the 1950s. Williams would have been entering his prime as the careers of Hogan et al. faded; Billy Maxwell and Don January would have been his contemporaries; his career would have connected Nelson and Hogan to Lee Trevino, Ben Crenshaw, and Tom Kite. Williams would be a popular elder statesman of golf today; a teacher, perhaps, or a player on the Senior Tour. But it didn't happen.

 Williams's father, a sportswriter for the Austin *American-Statesman*, didn't know beans about golf. Then in 1934, when the newspaper's sports editor asked his troops "Who wants to write about golf?" Williams volunteered. Soon after he started to write about the game, he began to play it. He got hooked. Williams, Sr., moved the family to a house by a nine-hole sand green golf course called Willow Springs (now Hancock Park) in Austin. There at Willow

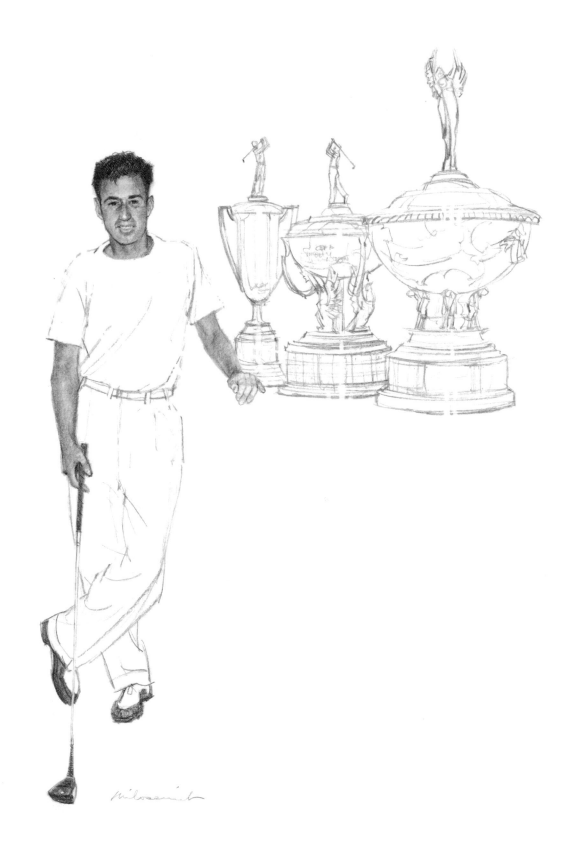

144

Springs, Williams father and son learned golf together.

Williams, Sr., soon decided that his son's golf potential was nothing to trifle with, so he turned him over to Austin Country Club golf professional Harvey Penick. Penick would eventually be Williams's coach at the University of Texas. "Harvey made a champion out of Morris, Jr.," his father said. "He would only have been a Sunday golfer going by my instructions."

In the late 1940s, the teenage Williams—slim, handsome and likeable—started to win golf tournaments. His most remarkable achievement was winning the "Grand Slam" of Texas golf. In a twelve-month period in 1949 and 1950, the eighteen-year-old Williams won the Texas Junior, the Texas Amateur, and the Texas PGA. No one had done it before. No one has done it since.

After a brilliant career as a UT golfer, Williams took a teaching professional job at Midland Country Club, then, with the Korean War raging, he entered the Air Force as an aviation cadet. While on an air-to-ground gunnery training mission, the F86 jet he piloted crashed. Morris Williams was dead at age twenty-three.

Freddie Tait, a well-known Scottish golfer, was killed at the turn of the century in the English colonial conflict in South Africa called the Boer War. Like Williams, Tait died young, too young, in the service of his country, and the world was deprived of his company. Andrew Lang's memorial to Freddie Tait would apply to Morris Williams, Jr.:

"Dozens of lads are proclaimed by the world of play but he would have been as much endeared to those who knew him if he had never handled a club."

Morris Williams, Jr., led UT to two Southwest Conference titles and to a second place finish in the 1949 NCAA. He also won the 1953 Air Force tournament.

Henry Dudley Wysong, Jr.

Born: McKinney
Residence: McKinney

I'm proud to have helped kids learn the game and appreciate its traditions.

Amost every golfer begins his or her swing with the club behind the ball. Not Dudley Wysong. In a truly startling departure from convention, Wysong begins his swing with the the club out *away* from the ball; he doesn't so much address the ball as he addresses the ground on the other side of it. Wait—stop—you want to say, you're going to shank it, Dudley, or miss it.

But Wysong doesn't miss it or mis-hit it. Instead he makes, sweet, solid contact with a beautiful, rhythmic swing. "I really learned this game from observation, not from taking lessons," Wysong says. "My dad was Byron Nelson's family doctor, so I talked to him a lot and watched him hit balls. I also listened to Hogan and Snead.

"No one ever asks *why* I address the ball that way. It's to prevent going over it and hitting a dart hook. I

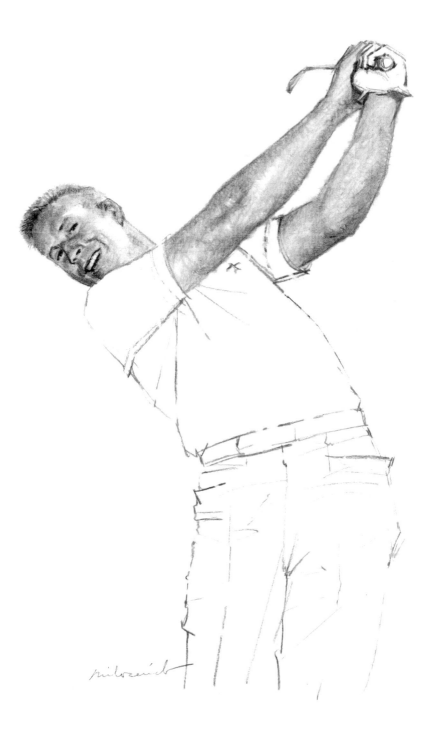

had a problem with that for a while. I'll tell you, a block is a lot better than an East Texas Bug Burner."

Wysong was introduced to golf by his parents at McKinney Country Club. He began to suspect he might have a future in the game in 1958, when he qualified for the United States Amateur and made the quarterfinals. He already knew he didn't want to be a physician, like his father and his grandfather. "Too many phone calls where my dad would say 'Well, George, how long has your chest been hurtin'? And George would say 'Oh, about three weeks.' And dad says 'Then why are you calling me at four in the morning?'"

Wysong made the semifinals of the Amateur the next year and the finals in 1961. His opponent in the thirty-six-hole final match at Pebble Beach was a big, blond kid from Ohio named Jack Nicklaus. "Jack back then was awesome. He hit it farther and straighter than anyone I'd ever seen," recalls Wysong. "It rained during the morning round and there was a twenty-mile-an-hour-wind. I shot seventy-three—and was five down."

After a moderately successful career on the pro tour, Wysong founded his own computer company and began doing the volunteer work that has been so satisfying for him. "I started a program with the McKinney YMCA to expose kids to golf—to tell them where it came from, how it started. I go out every afternoon [in the summer] to teach ten or fifteen kids at McKinney Municipal," says Wysong with pride.

"The great thing about it is getting poor kids out on the golf course."

Dudley Wysong won two PGA tour events and was the runner-up in the 1961 U.S. Amateur.

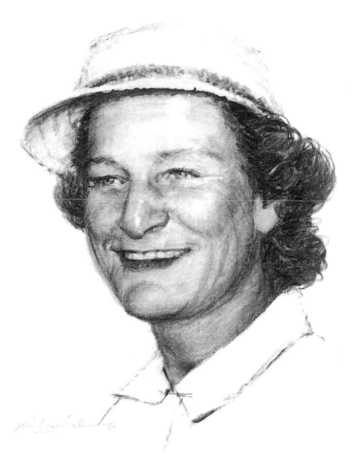

Mildred Ella "Babe" Didrikson Zaharias

Born: Port Arthur, 1911
Died: Galveston, 1956

Probably she was most proud of the U.S. Open she won in '54 after her surgery. But you know she never mentioned the Olympics? I've thought about that a lot. She kept her medals in a coffee can. Betty Dodd, the Babe's close friend

Bertha Bowen hands you a book, a yellowing, worn copy of *This Life I've Lived, My Autobiography* by Babe Didrikson Zaharias, as told to Harry Paxton. "It's my favorite, because it's the Babe's own words," Bowen says. You open the cover, see that it cost four dollars when it was released in March of 1955, and read the handwritten inscription: "For the dearest friends in all the world to me. Bertha and R. L. Greatfully [*sic*] yours, 'Babe'."

The Bowens were well-off Fort Worth golfers who befriended the Olympic heroine from Beaumont soon after she began playing golf seriously in the mid-1930s. Today, Bertha Bowen is ninety-four. She still

149

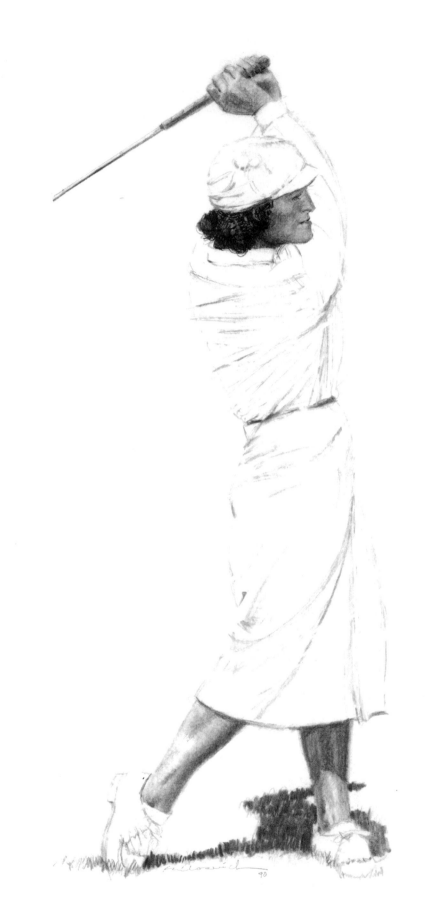

150

drives the Cadillac station wagon she bought for her eightieth birthday. She also gave herself a new set of Hogan golf clubs to put in the big, blue car. She is the kind of woman you imagine the Babe would have become had she reached old age.

"Many times when Babe was visiting, I'd wake up at two in the morning because of the noise of R. L. and Babe playing pool right here," says Bowen. Now that same pool table is covered with scrapbooks, magazines, and mementos of the Bowen's favorite house guest. "'You two get to bed, it's late,' I'd say. 'I can't quit 'til I win, B.B.,' Babe would say. She always called me 'B.B.'"

Bowen plucks a photograph from the pool table. The room smells of old newspaper. "Babe loved mountain stream fishing even more than golf. See this big fish she's holding? We had a ten dollar bet—whoever caught the biggest fish got the money. Well, Babe came up with this huge fish that didn't even grow in that water. Don't know where she got it," Bowen says. These reminisences, even the funny ones, are delivered with some sadness. Bowen misses her lively friend.

She comments that her late husband piloted his own plane. Babe loved to ride in it "Except she didn't like a smooth flight. If things were too calm, she'd say 'I don't like this. I want to do nip-ups.'" Mention of the plane spurs another memory: "In the finals of the Texas Women's Open in 1940, Babe wasn't playing too well. She was down after twenty-seven holes—they played thirty-six holes back then, none of this sissy stuff—so R. L. said to her 'If you pull this out, I'll fly you out to California to see George (Zaharias).'" Babe had been married to the hulking wrestler/ wrestling promoter two years. They lived then in Los Angeles. And despite a waistline that seemed each year to increase exponentially—"You used to be a Greek god. Now you're just a goddamn Greek," Babe would tease—she found Big George to be irresistible.

"Well, Babe picked up her feet and she won," continues Bowen. "They hit weather over West Texas. Frank Goldthwaite was on the plane and he said he dipped snuff over Amarillo and didn't spit until L.A." But Babe didn't mind the bumpy flight.

Bowen searches for and finds a United States Golf Association record book under some old newspapers on the pool table. "You see, Babe was simply the best. Just look at what she did in the U.S. Women's Open, how much she won by." Zaharias won the 1948 Open by eight shots, the 1950 Open by nine and the 1954 Open by a record twelve shots. The 1954 win was her most amazing. Babe had had surgery for colon cancer and a colostomy a year before. And cancer would kill her two years later.

The genesis of the Babe Didrikson Zaharias legend was simple: at a time—the Depression—when the United States was aching for heroes, when sports writers turned successful athletes into demigods—and readers believed the hyperbole—Mildred Didrikson seemingly tried every sport and won in every sport she tried. Her timing was perfect.

As William Oscar Johnson and Nancy Williamson wrote in their excellent biography *Whatta-Gal* (published by Little, Brown, 1975), "Against this bleak backdrop Babe Didrikson's star rose, and she experienced personal triumph so intense that only a few human beings—prime ministers, presidents, generals, astronauts—ever come near it."

Probably the key to the Babe's unprecedented success, more important even than her physical ability, was her absolute compulsion to win. "All my life I've always had the urge to do things better than anyone else," she wrote in her autobiography. She had to win the fishing contest with the Bowens, had to beat R. L. in pool, had to win the U.S. Open. And the topper, the part the sports writers loved—and her competition hated—was that the Babe told you she was going to win.

Take, for example, this incident Zaharias recounts in the autobiography, when she first met her teammates on the Employers Casualty (of Dallas) basketball team: "One of them, Lalia Warren, said 'What position do you think you're going to play?' So I got a little pepped up there, and I said 'What do you play ?' She said 'I'm the star forward.' I said, 'Well, that's what I want to be.' And that's the way it worked out, too."

After basketball (two national titles in three years for the company team), the Babe tried track. She won the 1932 Amateur Athletic Union *team* title—by

herself. Two weeks later, in the Los Angeles Olympics, she entered the maximum of three events. She set three world records and won two gold medals and a silver in the high jump, high hurdles, and javelin. Babe Didrikson, a poor girl with a bad haircut, was suddenly a star, perhaps the brightest star in the country. There were parades for her in Dallas and Beaumont, key to the city presentations, interviews, adulation. Then she took up golf.

"Weekends I put in twelve to sixteen hours a day on golf. During the week I got up at the crack of dawn and practiced from 5:30 to 8:30," wrote Babe in her autobiography. After work, "George Aulbach (the pro at Dallas Country Club) would give me an hour's instruction. Then I'd drill and drill and drill . . . until my hands were bloody and sore. I'd have tape all over my hands and blood all over the tape."

Babe won every major amateur golf tournament in the next decade and a half, then helped form the Ladies Professional Golf Association (LPGA) in 1950. "I remember playing in one of those first tournaments with Babe, and I was nervous," recalls Marilynn Smith. "So Babe put her arm around me on the first tee and said in a loud voice, 'I always like playing golf with you Smitty. You really bring out the crowds.'" The gallery laughed, of course. They were there to see the Babe. But the humor relieved Smith's tension and made her a Zaharias fan for life.

Peggy Kirk Bell, another top golfer of the day, also remembers the Babe fondly. Bell played with Zaharias in the Babe's final round of golf in October, 1955. "Babe was always on, always entertaining," says Bell in *Whatta-Gal*. "When she was dying in Galveston, she was still going to entertain you. I went to visit her and she said 'See that Coke bottle over there?' And she promptly flipped a cigarette into it. She was always doing the impossible. If she missed, no one remembered. When she made it work, it became legend."

Babe Didrikson Zaharias won fifty-five amateur and professional tournaments. During a streak of seventeen victories in a row, she won the U.S. Women's Amateur in 1946 and the British Women's Amateur in 1947. She was the Woman Athlete of the Year six times, was voted Female Athlete of the Half Century in 1949, and won the Vare Trophy and the Ben Hogan Award. She is in the LPGA Hall of Fame. Of her thirty-one professional wins, five were major titles, including three U.S. Women's Opens.